David Hockney

paper pools

David Hockney

paper pools

Edited by Nikos Stangos

with 122 illustrations
87 in colour

Thames and Hudson

The author and publisher gratefully acknowledge the
help of Gregory Evans in the preparation of this book.

Filmset in Great Britain by
Keyspools Limited, Golborne, Lancashire.
Printed and bound in the Netherlands

Preface

Paper Pools is the most recent major group of works by David Hockney, demonstrating his fascination with new techniques in the service of his passionate pursuit of creative representation. In 1976, Hockney had become obsessed with the technique of coloured etching, which he had been taught by the French print-maker Aldo Crommelynck and which resulted in the Blue Guitar series, among other inventive works. Now Hockney has applied himself with infectious enthusiasm to the making of Paper Pools, in which painting and paper-making are totally fused.

The challenge to his imagination and creative ability of mastering a new technique, learning its limitations, accepting these limitations and transcending them is the same as that which has provided the fuel in all the new phases of his work. It was perhaps a similar challenge – and also the arbitrary limitations imposed by failing health – that led Matisse to his paper cut-outs, of which especially relevant here is *La Piscine* (1952), which are among his most thrilling and innovative works, and which Hockney must have had in mind when he was making Paper Pools.

But his keen, lively and humorous eye probably looked elsewhere too: Monet's monumental essays on the representation of water in the works of his later years, for instance. Water is a subject which has fascinated Hockney continuously; his element seems to be water, at least since 1964, in such works as *Picture of a Hollywood Swimming Pool* (1964), *Swimming Pool* (1965), *Two Boys in a Pool, Hollywood* (1965), *Different Kinds of Water Pouring into a Swimming Pool, Santa Monica* (1965), *Peter Getting out of Nick's Pool* (1966), *Sunbather* (1966), *Portrait of Nick Wilder* (1966), *A Bigger Splash* (1967), *Pool and Steps, Le Nid du Duc* (1971–2), *Portrait of an Artist (Pool with Two Figures)* (1971) and in numerous other drawings, paintings and prints.

Hockney made these works in the same workshop – Tyler Graphics Ltd, near Mt Kisco, in New York State – in which other artists had also tried this technique: Paper Pools makes oblique references – although ambiguous ones, given that their work is abstract whereas his is representational – to Ellsworth

Kelly, Frank Stella and Kenneth Noland. Hockney's fascination was in using a watery medium for the representation of a watery subject, bringing together many of the themes he most loves: the paradox of freezing in a still image what is never still, water, the swimming pool, this man-made container of nature, set in nature which it reflects, the play of light on water, the dematerialized diver's figure under water.

Hockney collaborated with the staff of Tyler Graphics Ltd, from August to October 1978, on Paper Pools, which consists of twenty-nine pressed colour paper pulp pictures.

After a few days of making sample colour papers to develop a working knowledge of paper-making, Hockney made his first picture, *Sunflower*. He then decided that he needed a subject which would allow him to create images in bold, simple colour forms. He selected Ken Tyler's swimming pool, near the workshop, as the subject for this series of essays in paper. For days he studied the pool, drawing and photographing it extensively at different times of the day and night, observing the many light and colour changes. These studies were often made with his model, Gregory Evans, who posed in various positions in the water and around the pool. As Hockney defined the range of colours he intended to use, Ken Tyler and Lindsay Green mixed and tested colour pulps to match his colours. Using these paper tests, his drawings and numerous photographs, he made final coloured line drawings to scale. In the beginning, these drawings were small, then 42 x 32 (107 x 81), then $50\frac{1}{2}$ x $33\frac{1}{2}$ (128 x 86), and finally, the largest three panels, 72 x $85\frac{1}{2}$ (183 x 218).

From these drawings, special metal moulds were constructed from $1\frac{1}{2}$-inch strips of galvanized sheet metal, which were cut, bent and soldered together. The moulds were designed to make the artist's line drawings into simple bold forms. The cloisonné-like moulds were placed over wet flat sheets of newly made paper, creating open compartments for receiving the liquid colour pulp, which was poured into them and directly onto the wet base paper. After all sections of the moulds were filled in with colour pulp by the artist, assisted by

Tyler and Green, the moulds were carefully removed and Hockney then finished colouring the work by directly applying coloured pulp and liquid dyes freehand.

A variety of tools and techniques was invented by Hockney and Tyler to colour the works. Liquid colour pulps were spooned, poured, painted and dropped onto the pieces. Sometimes Hockney softened hard edges by blending and patting coloured pulp areas with his fingers and hands. Dog combs, toothbrushes, fingers, a garden hose and working outside in the rain were used to obtain textural effects. He usually applied liquid dyes with a kitchen baster or a paint brush, but on several occasions sprayed it on with an airbrush.

After Hockney finished colouring the works, they were individually pressed between felts in a hydraulic press under great pressure which fused the layers of coloured pulp and began the drying process by removing excess water. Sometimes the paper works were pressed only partially, allowing the artist to make necessary additions and deletions that were only possible in the half-pressed state. The papers were then further dried between wool felts and blotters by numerous hydraulic pressings.

Nikos Stangos

Acknowledgments

Reproduction of the Paper Pools courtesy of Tyler Graphics Ltd; reproduction of drawings courtesy of Knoedler Kasmin Ltd; polaroid photographs by David Hockney; photographs on pages 8, 20, 38, 93 by permission of Lindsay Green; photograph on page 25 by Gregory Evans; photographs on pages 11, 53, 72, 73, 92 by permission of Jill Richards; photograph on page 96 by John Kasmin; all photographs of the Paper Pools by Stephen Sloman. The publisher would like to thank especially Kenneth Tyler and Lindsay Green, without whose help this book would not have been possible. In the captions of the Paper Pools, measurements given are of the overall work, first in inches then in centimetres, height before width.

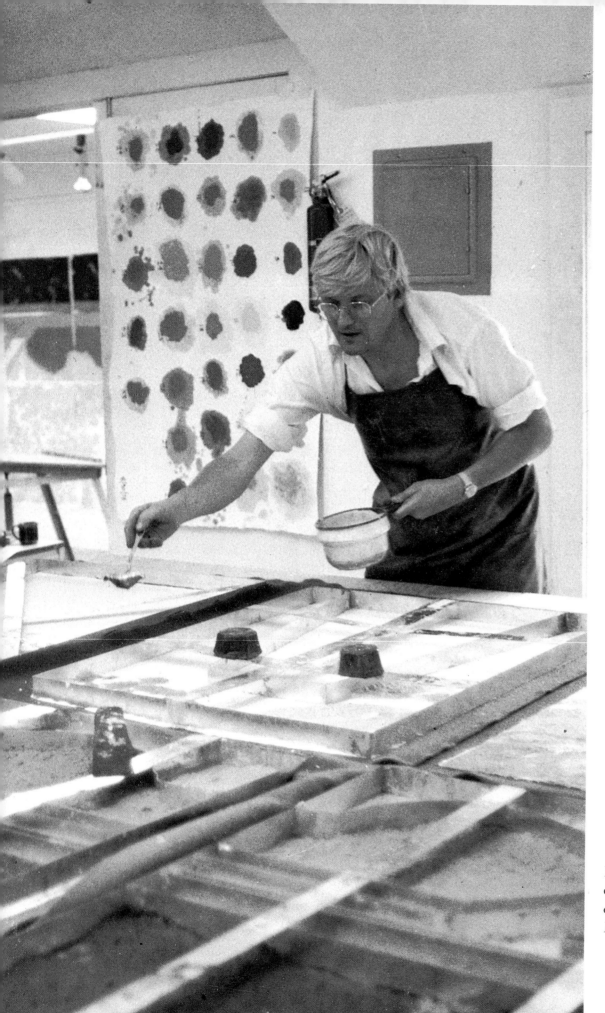

Hockney putting
coloured pulp in moulds
of *Swimming Pool with
Reflection* (Paper Pool 5)

Making Paper Pools by David Hockney

For almost a year, between the summers of 1977 and 1978, I had been designing an opera, *The Magic Flute*, and I finally began to get a little frustrated. Working in the theatre involves many compromises with a lot of other people and a painter is not quite used to that; you like to do the work yourself, to do it alone, you are very used to that. So, after a year, I decided I didn't want to do anything more in the theatre for a long time. I wanted to go back to painting, and I thought I would not stay in England, I couldn't do it in England; I decided to go to California where they leave you alone and I could just paint all alone. I even planned to fly from London to Los Angeles without stopping anywhere, and then I felt I had friends in New York and I'd just stop and see them.

Just before I left England – this was in August 1978 – I'd lost my driving licence. In England it didn't matter, but I thought, what am I going to do in California? I couldn't even rent a car, and they'd put you in prison if they found out. So I applied for another one, but it took a long time and it hadn't come when I left. I didn't know what to do; I thought, well, maybe I'd stay in New York until I got it, then I would go to California.

An old friend, Kenneth Tyler, who was a lithographic printer in Los Angeles and used to run a workshop there called Gemini, a very energetic person, was always trying to get me to go to his workshop just north of New York City to do some work. He kept phoning me up and he sent me a great big apple, a bronze apple, and he tried anything he could to make me think of New York. But I didn't want to do any kind of graphics work; as I said, I was a bit fed up with working always with other people and I just wanted to go off on my own and I wanted to paint. But I went up to see him and to say this to him. I'm not very good at saying, I don't want to come here and I don't want to do anything with you; I find it very hard, really hard at times to say no, especially when people are charming; I fall for it all the time. I began telling him I didn't want to do any lithographs and he started showing me some recent works that were made with paper pulp, things he had done with Ellsworth Kelly and

9

Kenneth Noland. They were stunningly beautiful, I thought, especially Ellsworth Kelly's; I thought they looked so good, and I responded. I said, they are very, very good, beautiful, Ken, but I'm on my way to California. I had gone up to Tyler's workshop with a friend of mine and he said, well, you know, if you like these pictures why don't you stay three days and do something, try it out. So, I said I'd stay in New York – it was only forty-five minutes' drive out of the city.

Ken started showing me the process. I love new mediums and this was something I had never seen or used before. I think mediums can turn you on, they can excite you: they always let you do something in a different way, even if you take the same subject, if you draw it in a different way, or if you are forced to simplify it, to make it bold because it is too finicky. I like that. So I said I'll have a go and I started doing a few things, but I wasn't that keen on it at first, although I began to see there were possibilities. The process involved making a piece of paper from scratch, from rags. I had never seen paper made before: you chew up rags in a machine and it's all done with these chewed-up rags and water; you put it in a vat and you have a thin mould, which is all made of wire, and you dip the mould in the vat, and as you pull it out, all the water runs out through the wire and this thin layer of mush stays there, and you tip it out onto a piece of felt, and when it dries it becomes a piece of paper. Or you can press it, press the moisture out, and when all the moisture is gone, all the rags stay together and it becomes a piece of paper. Ken explained that you could add dyes to the pulp and the colour would be more vivid and stronger than applying paint on the surface. I didn't quite understand, so he explained it to me again and we tried it and I began to see some possibilities.

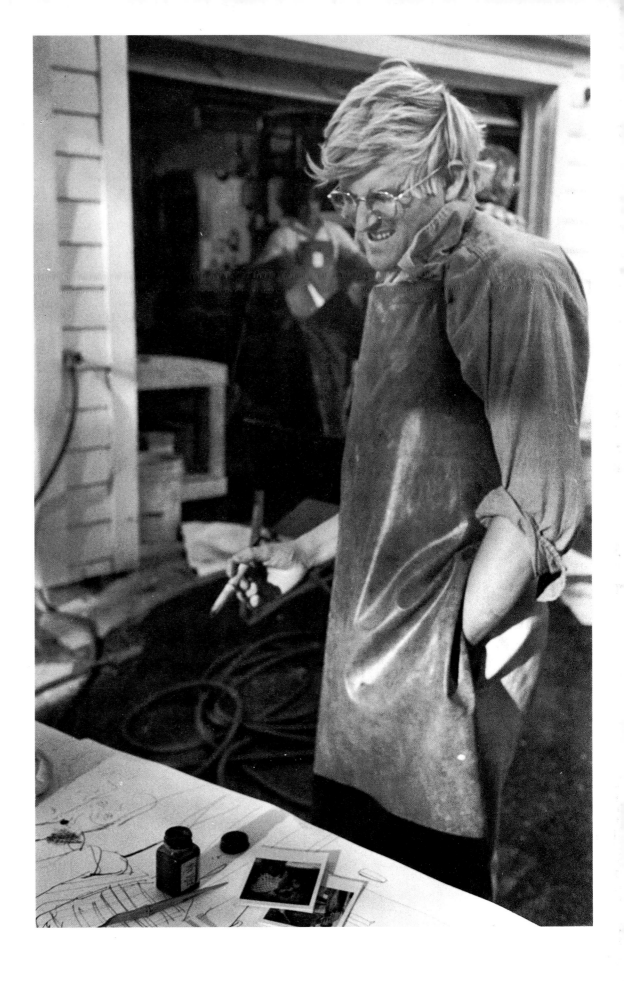

Drawing of a corner of the paper-making
workshop at Bedford Studios (Tyler
Graphics). *Overleaf*: Kenneth Tyler and
Lindsay Green who made the paper and
assisted Hockney in making Paper Pools

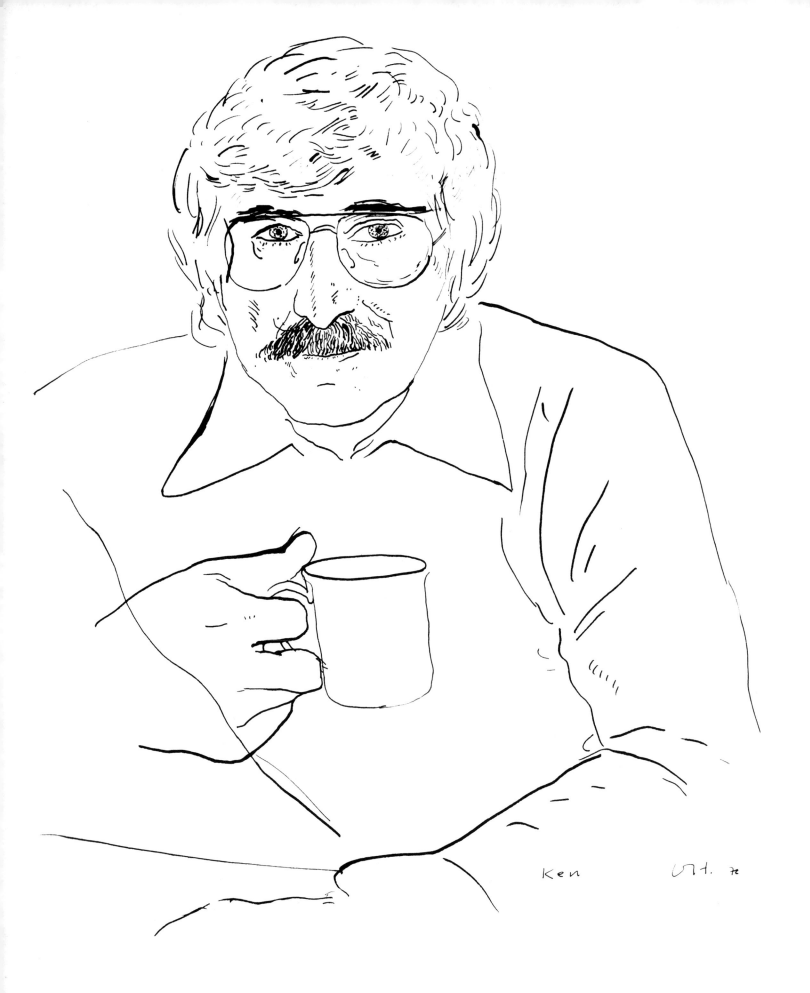

Ken uH. 72

Kenneth Tyler and Lindsay Green (*below*, *opposite* and *overleaf*) showing the process of tipping a wet sheet of freshly made paper onto damp woollen felt

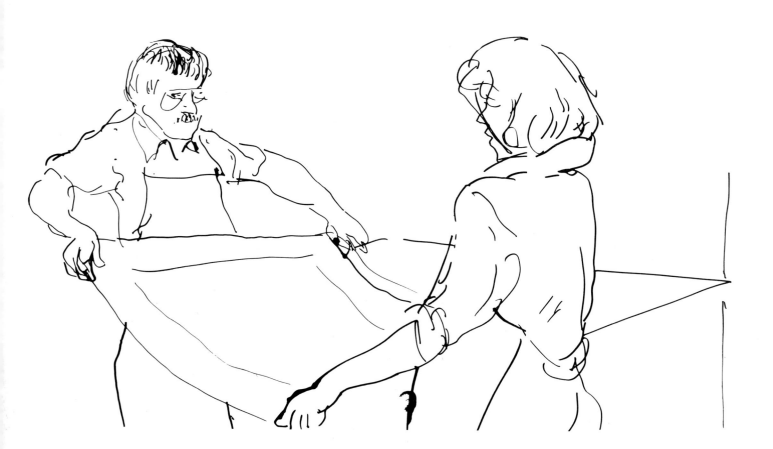

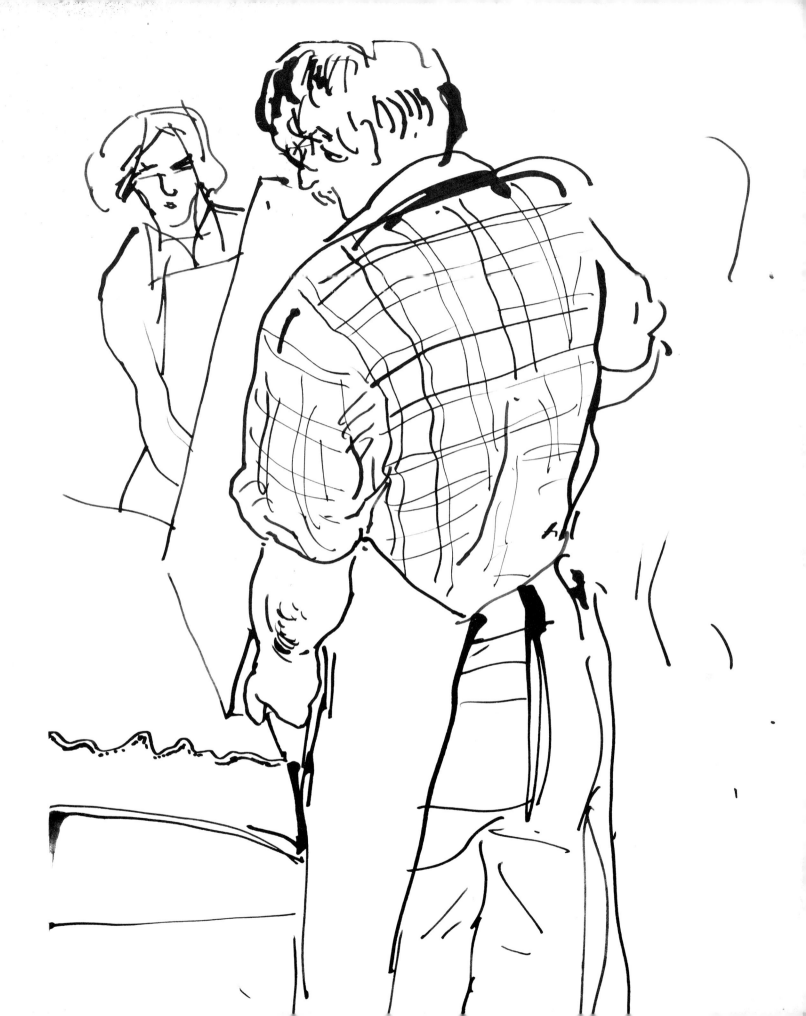

Kenneth Tyler at outdoor platform laying down the metal moulds for *Midnight Pool* (Paper Pool 10) before the liquid coloured paper pulp (in lettered buckets on the left) was to be poured or spooned into the moulds

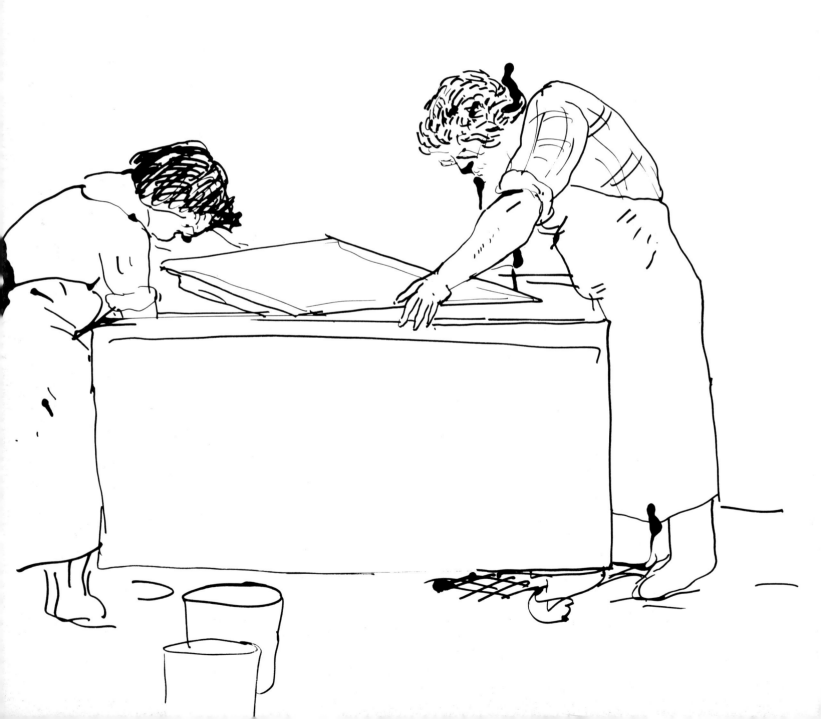

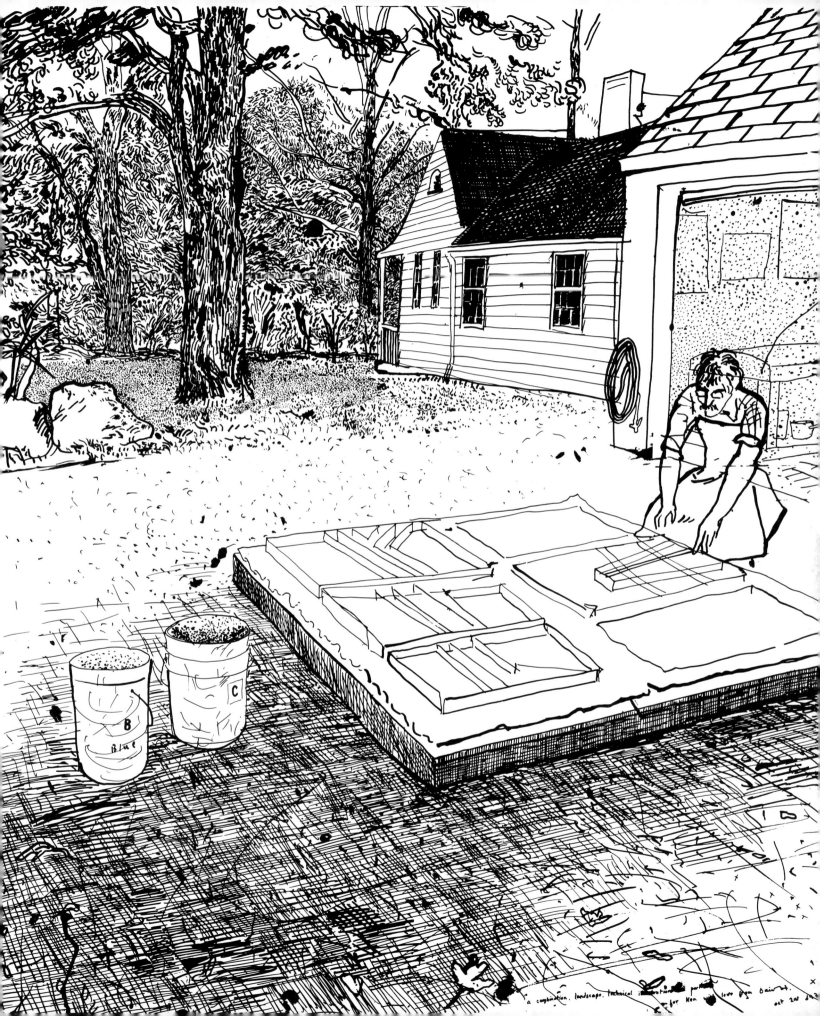

a combination. landscape. technical illustration. portrait.
for Ken with love from David. oct 2011

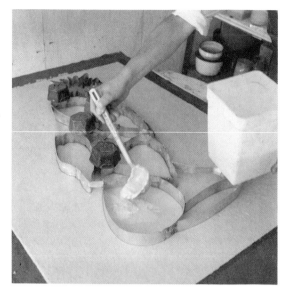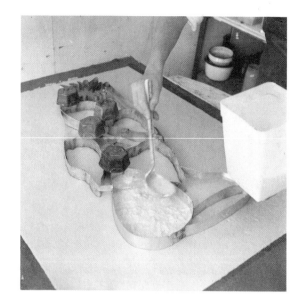

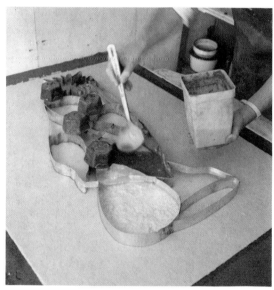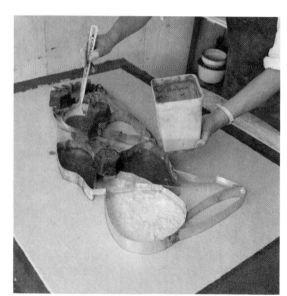

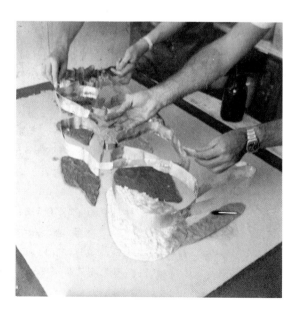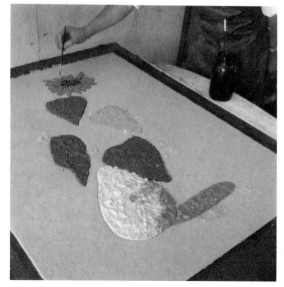

The moulds for the first work in the series, *Sunflower*, with Hockney and assistant filling them in with coloured pulp, using a soup ladle. Hockney then adjusted the colour with a brush. *Overleaf:* five versions of *Sunflower* (Paper Pool 1), 42 x 32 (107 x 81)

I drew flowers at first; I thought, I like flowers, I'll draw flowers. Using this process, you are forced to be very bold, and you cannot be finicky with it, you can't use lines at all. At first I said, I love using lines, Ken, I'm not very good at using colour, bold colour, I'm too timid with it really. But gradually I realized that you could work with moulds, as if 'drawing' the form with little metal moulds, and pour all the colours next to one another. I was drawing sunflowers; I drew the leaves on the stems, and then Ken said he would make the mould of just the leaves first, and I could draw in the stems myself. We made the moulds and then I looked at it and I realized that you didn't really need the stem at all; it was there.

We were thinking that it was like a graphic process and that you made an edition, like a lithograph. We made a metal mould and we made ten of these sunflowers. But then I realized that it was totally unlike a graphic process in that I had to make each and every work myself. We weren't making prints at all. Prints, after all, are exactly the same in an edition, and these were not. I couldn't walk away and ask Ken to print them; with a lithograph I could do that. I didn't like the idea of having to do all this myself; it would be boring if they all looked the same; I said, we will do five; Ken said, we will do ten, and it took us a day to make ten.

The driver's licence still hadn't arrived, so I couldn't leave, and I carried on, and we tried other things. Ken had a swimming pool in the garden and every day we would have lunch by the swimming pool, every lunch-time I would have a swim. I kept looking at the swimming pool; and it's a wonderful subject, water, the light on the water. And this process with paper pulp demanded a lot of water; you have to wear boots and rubber aprons. I thought, really I should do, find a watery subject for this process, and here it is; here, this pool, every time that you look at the surface, you look through it, you look under it.

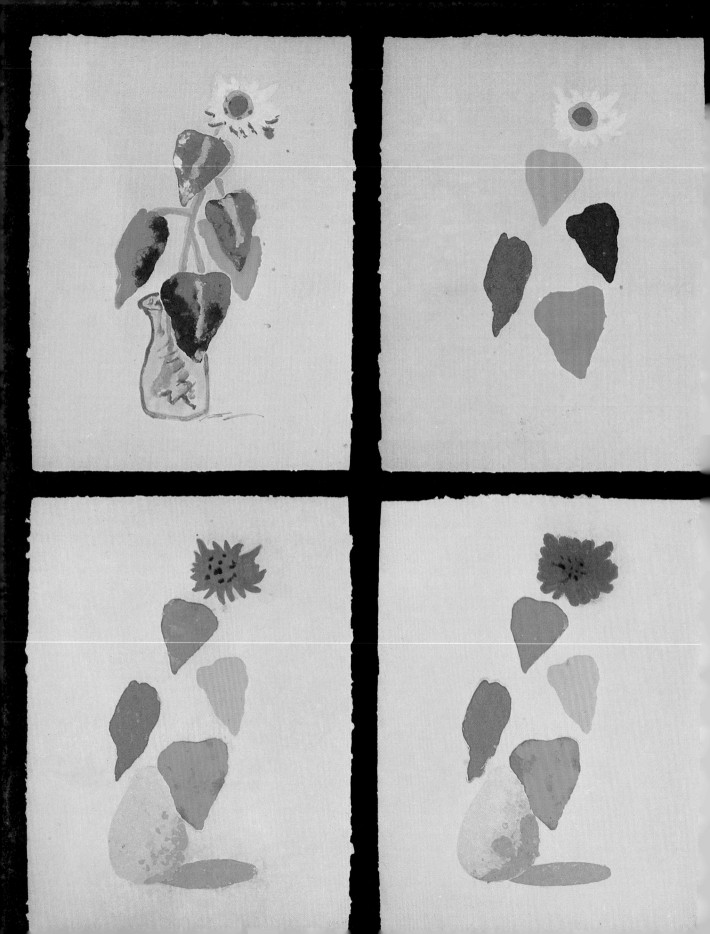

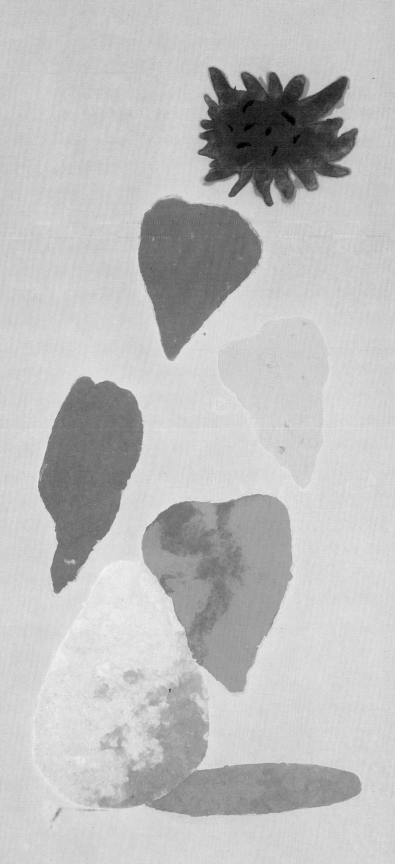

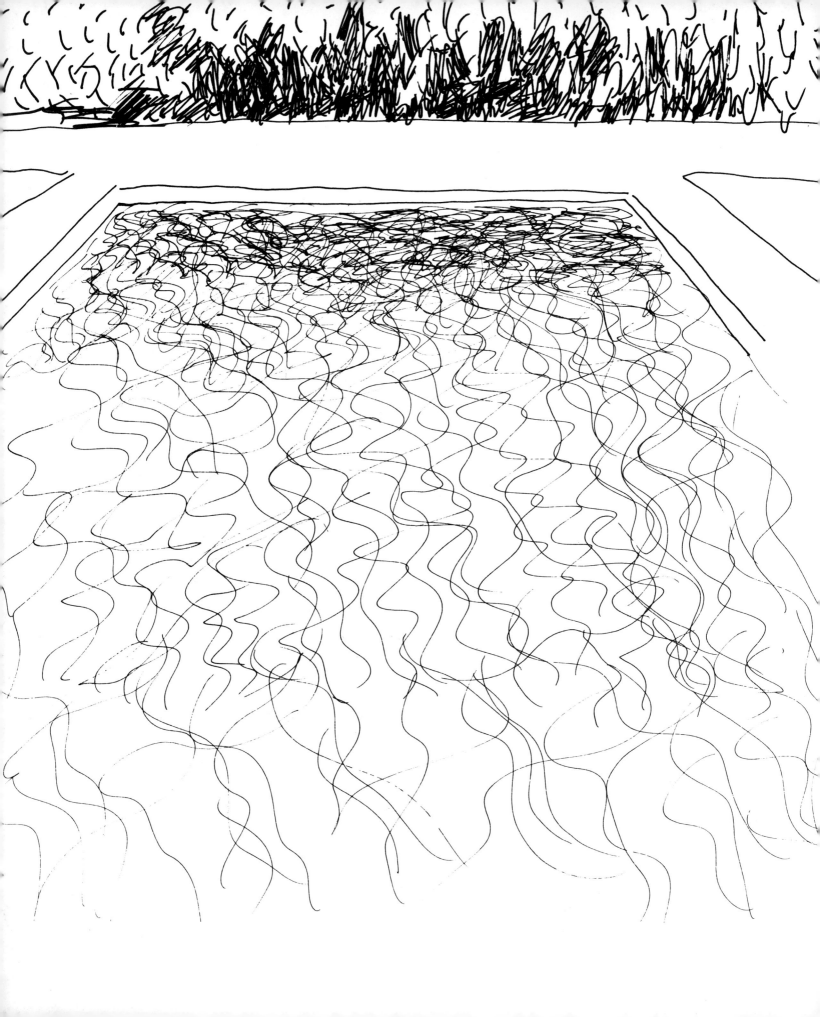

It dawned on me that the swimming pool was a much more interesting subject. I tried to figure out how to begin it, how to do it. I had been taking some photographs with an sx70 camera. In the late afternoon the shadow began to fall on the pool steps. I was taking photographs of that and of bold patterns in the water. And after this, I began to try this idea out with the paper pulp process: the mould was at first very simple; the blues, where the colour changes to a different shade, are just pouring in pulp and then making it stronger by adding more to it, making it denser, or changing the colour. The shapes of the steps were made simply, cut from a biscuit mould. I put them down and again poured different colours in. But we still thought it was like a graphic process, that you could make a number of them, except that I would have to do them each time. If Ken did it while I wasn't there, he probably wouldn't get the watery effect at all; so I said, well, I have to do it again; that means I don't want to do that many, I'll make one or two.

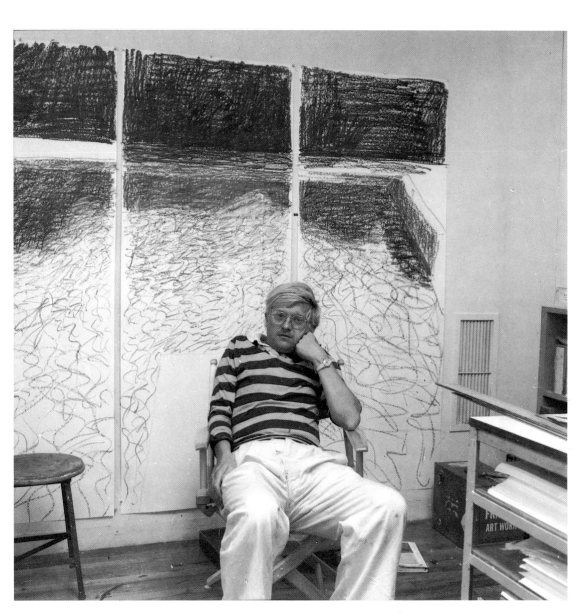

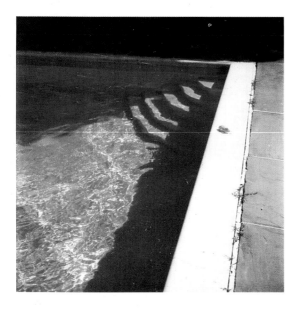

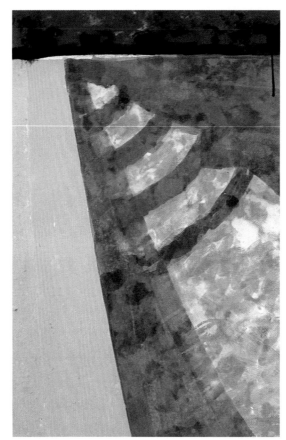

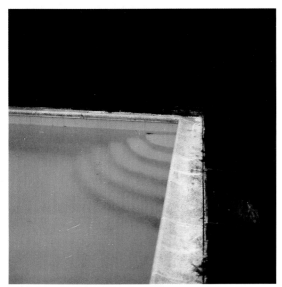

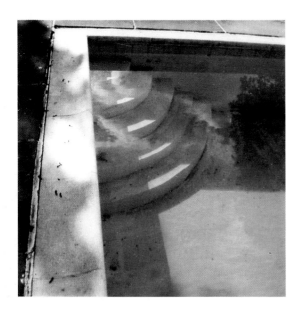

Polaroid photographs taken by Hockney of the steps going down into the swimming pool, and three versions of *Steps with Shadow* (Paper Pool 2), $50\frac{1}{2}$ x $33\frac{1}{2}$ (128 x 86)

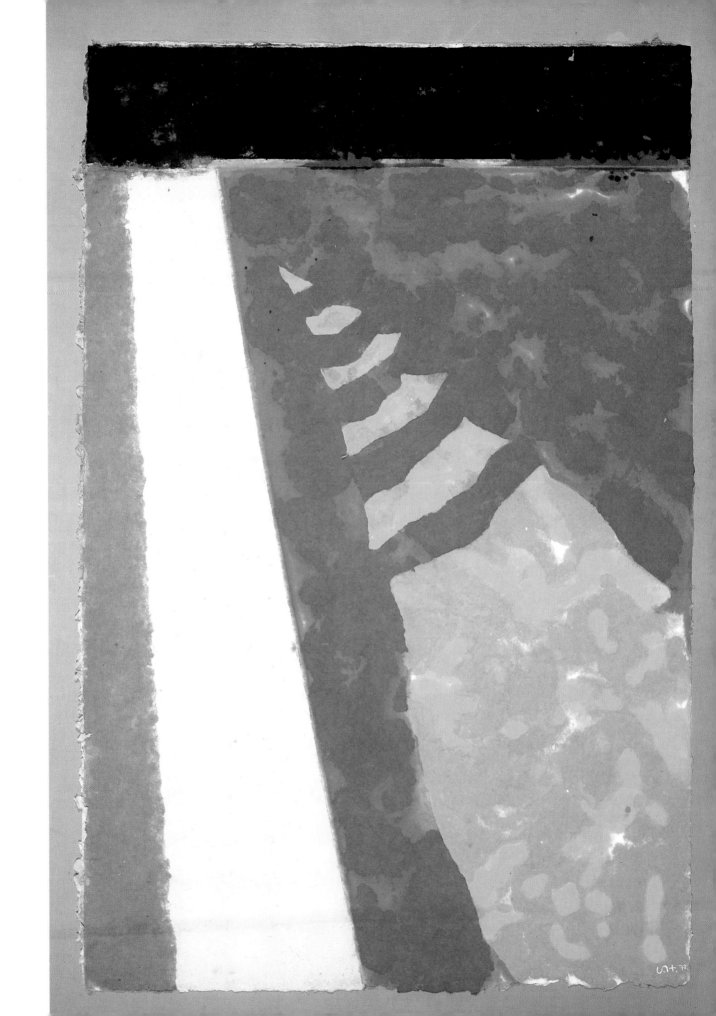

I kept looking at the swimming pool and the shadows falling from the diving board, things in the water dancing around. The shapes of the moulds are very simple and the only things different are the greens or whites which show through the original, ground paper pulp. I kept pouring on this green with a spoon, and the white looks as though the water is dancing about. You had to put on the colour well, very carefully, and I couldn't rely on someone else doing this. At least, I thought, I could be freer, because if I made a mistake it doesn't matter: who can I blame? I can't blame anybody.

Drawing of Bedford Studios with drawings pinned on the wall of, from left to right, a section of *Swimming Pool with Reflection, Sunflower* and *Steps with Shadow* (Paper Pools 5, 1 and 2), and of friend, Peter Schlesinger

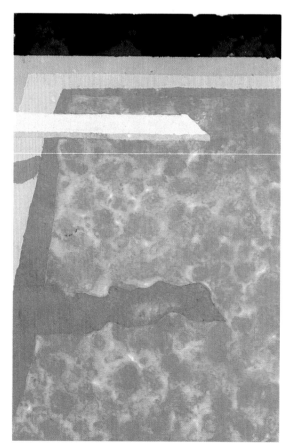

Polaroid photographs–
including one of pulp before
pressing–relating to three
versions of *Green Pool with
Diving Board and Shadow* (Paper
Pool 3), $50\frac{1}{4}$ x $32\frac{1}{2}$ (128 x 82)

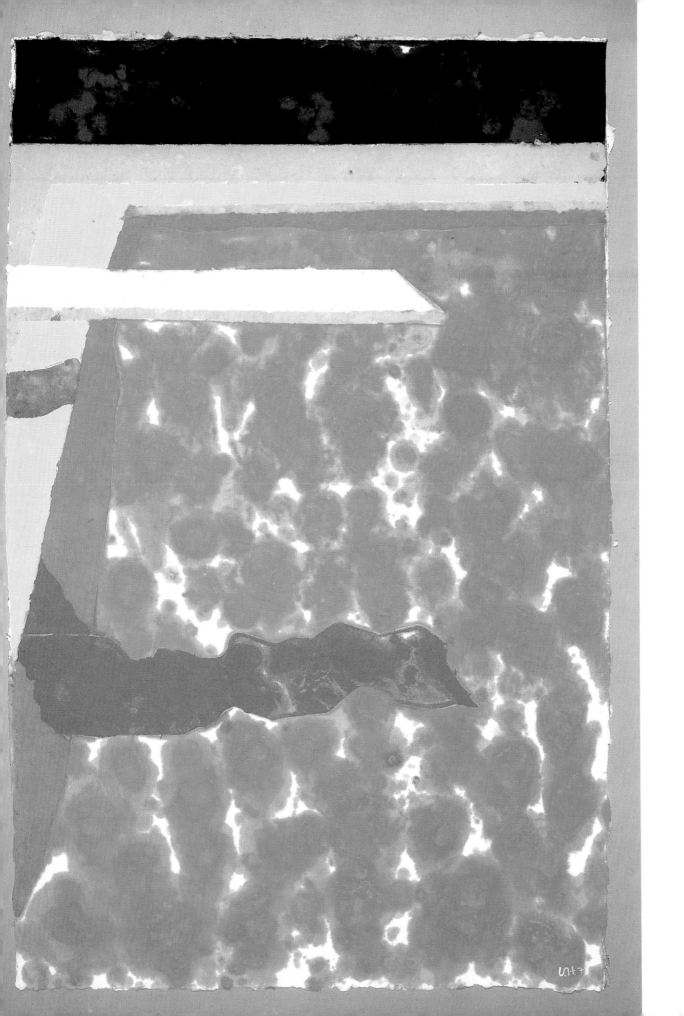

Drawing for *Gregory in the Pool* (Paper Pool 4)

Polaroid photographs (*opposite*), and a close-up of coloured pulp before it was pressed, relating to four versions of *Gregory in the Pool* (Paper Pool 4)

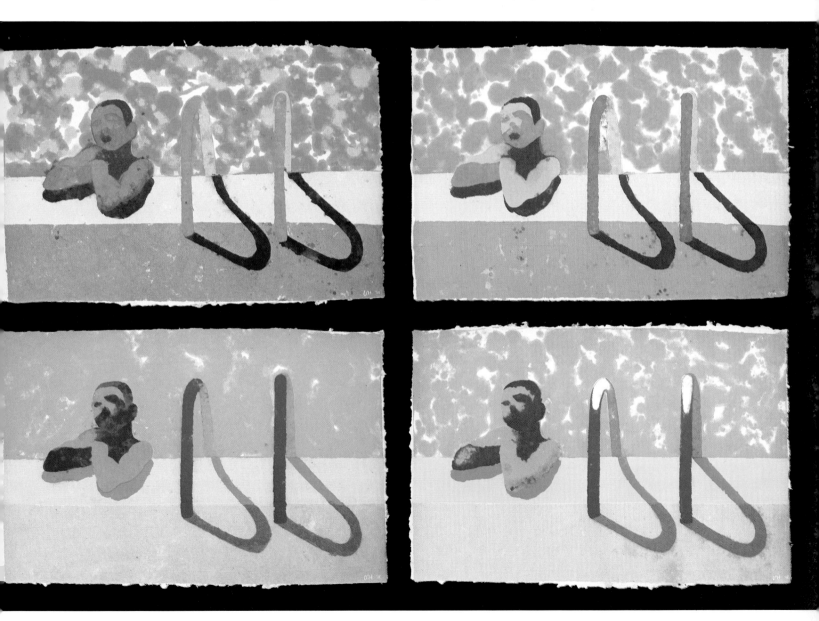

And so we made about eight like that and I was getting a bit fed up, really; I thought we should make them bigger. Because the medium was so bold, you had to be bold in other ways. I thought the paper should be bigger, but Ken said you couldn't make a piece of paper bigger than this because you would need an extremely large vat and an extremely large press and they hadn't got it and it would be too expensive. So I suggested that we could make six pieces of paper and lay them down and I could treat them as one and I could take a big spoon, or pour the colour and make one picture. I said, look, here is this swimming pool; every day we sit in the same position, every day it looks different; why don't we do this, and I'll draw a very simple composition and within that we can put in different effects of light. So I drew out this very simple composition, and I said, we don't have to make them all the same at all, we can make them different.

Soon I didn't like doing everything without figures, and I added Gregory in the pool, whose figure was the ground paper itself. I drew the figure out very simply, then I made the mould, and used two pink colours which I put together and then I kneaded them with my fingers which I thought was nice because it's nice to do that to flesh. It was a good contrast to the effect of water and the effect of shadow. But I still wanted to try to do bigger ones. First Ken thought I could perhaps do each piece of paper separately. I said, I think you have to do them all at the same time. He said, then you will need a big table and it's going to be very tricky, the flies are going to come on it and the leaves are going to fall on it – we were working outside. I said, I don't know, that's all I can think we can do. And so he set it all up.

Gregory in the Pool (Paper Pool 4), 32 x 50 (81 x 127)

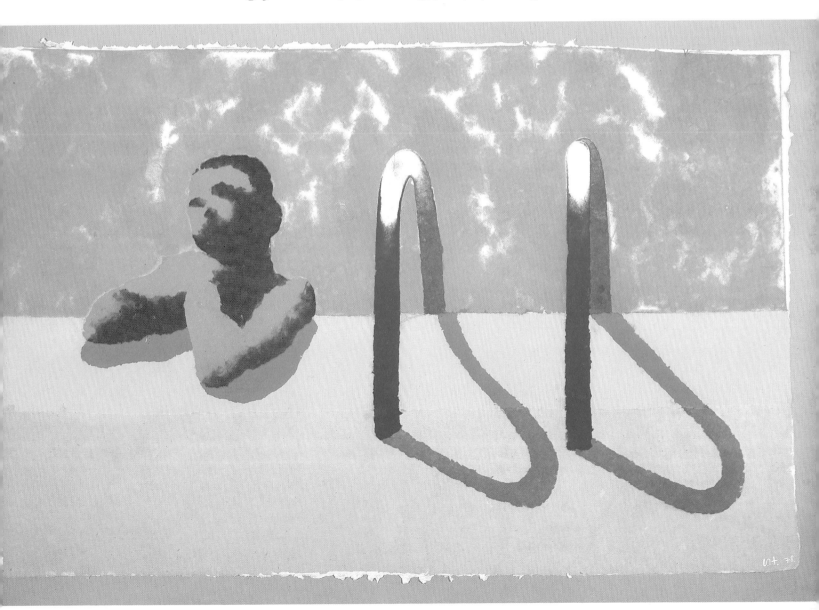

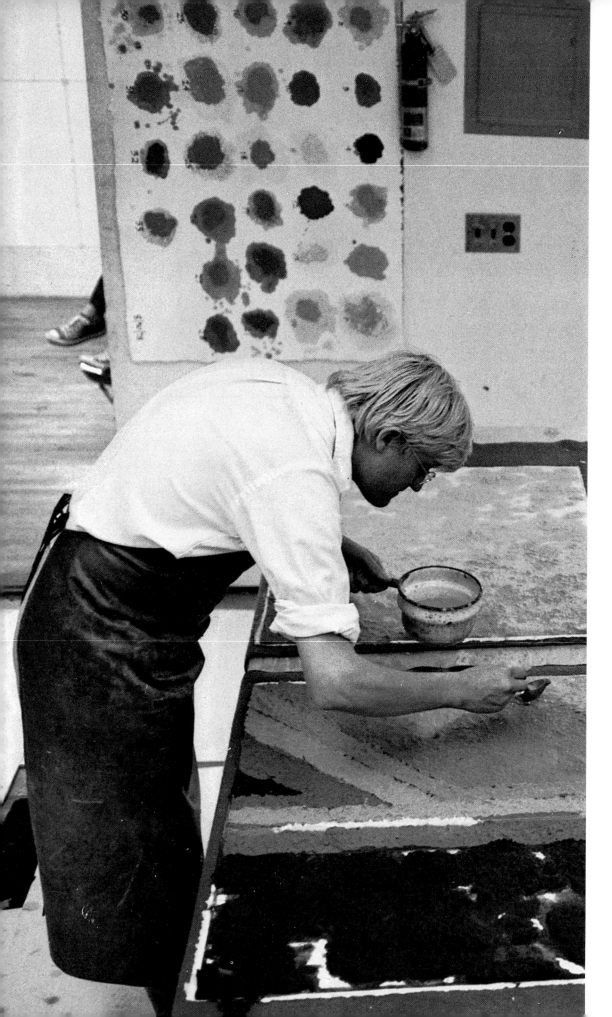

Hockney adjusting the colour of Paper Pool 7; in the background, dye tests of coloured pulp

There were quite a few times when there was nothing much for me to do, and I started drawing him and Lindsay Green, his assistant. I started drawing them doing the paper-making and pulp-colouring process by putting colour into the white paper pulp. I drew them with a big reed pen, very, very bold drawings. Ken wanted me to take photographs of the process. I said, that's a real bore, to take photographs, when I'm an artist here: I'll draw them myself. I'd already begun to get bored with photography. I said, if Van Gogh were here he'd draw them, wouldn't he.

Some of the colours, I noticed, were extremely strong. Later on, he ran out of the blue we had been using and he pretended that he hadn't and that he still had the colour, and I said, it's not the same; I can see it's not the same, it doesn't act the same. He thought I wouldn't notice, and I said, I notice what I'm painting with and what exactly it can really do.

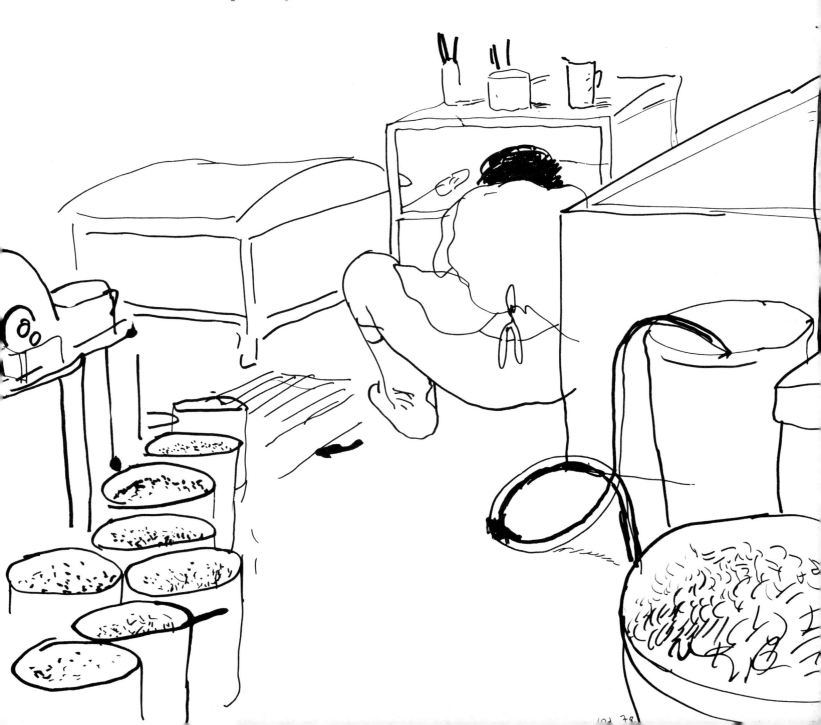

After we made the first one with six sheets of paper, we started another one, of just the reflection of the trees behind the swimming pool; it was just looking at the surface: you could look at the surface of the water one way, then you could look into the water and see different things. I was trying to show the depth of the water and the surface of the water.

The image size of each panel comes out to 6 ft x 7 ft, and each of the big works is seven feet long. When we had finished the first one, I said, pin the panels up. Ken was very loath to pin them up; he said, this is very beautiful

Swimming Pool with Reflection
(Paper Pool 5), 72 x 85½
(183 x 218)

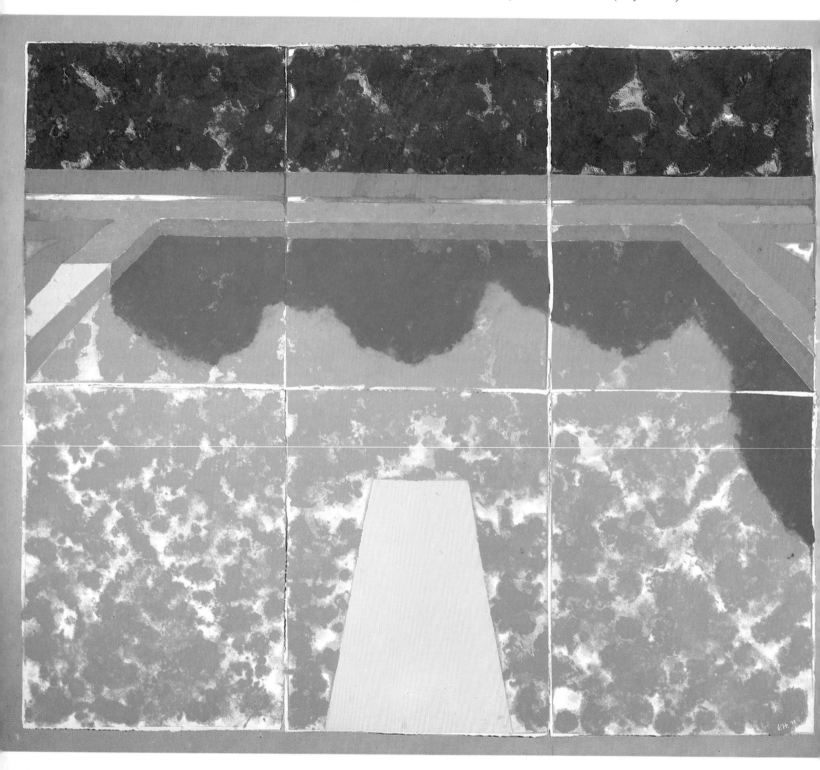

paper and you shouldn't stick pins in it. So I said, you know it's not fair; if you want them to grow, you have to stick pins in them and then we can look at it. So he did stick them up and he left them up. Then I thought they should get simpler, that they were not simple enough; and, simplifying them, the subject could change; all you were doing now was looking at the surface of the water, you weren't looking into the water at all; so all you were doing was looking at a flat plane. And depending on the weather, whether it was cloudy or sunny – each day was different—you could look right through it, into it, onto it.

Piscine avec trois bleus
(Paper Pool 6), 72 x 85½
(183 x 218)

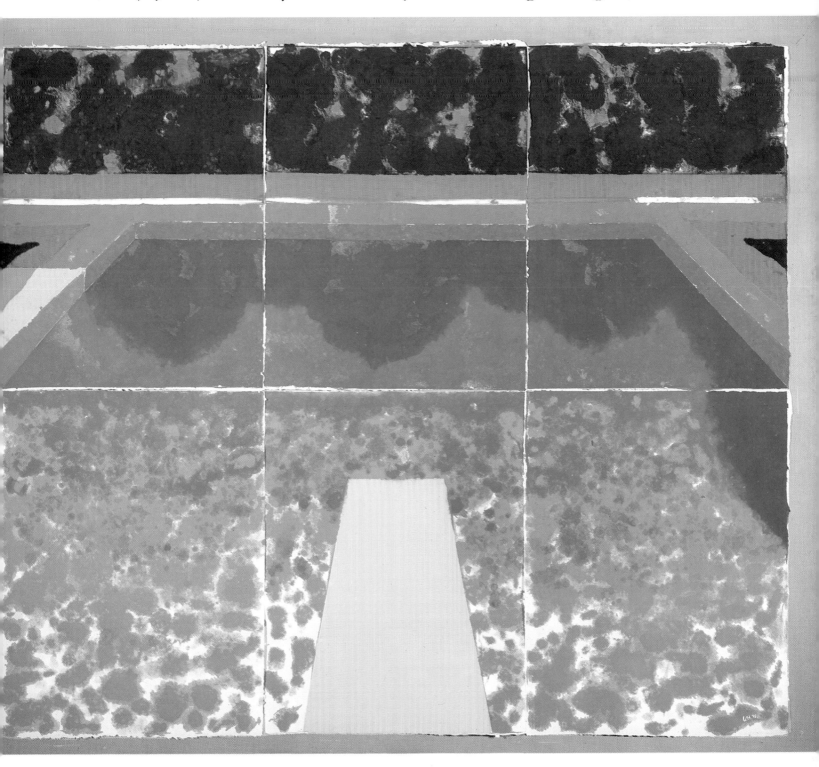

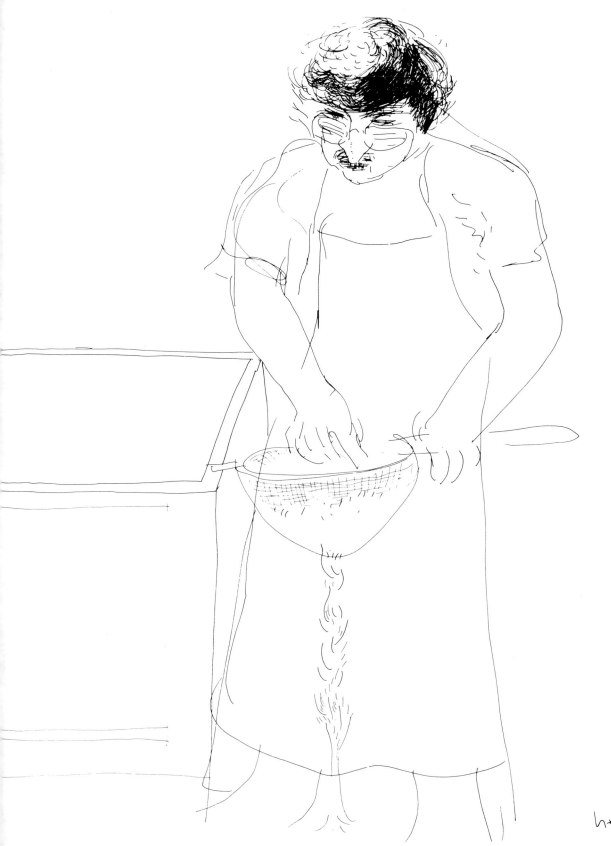

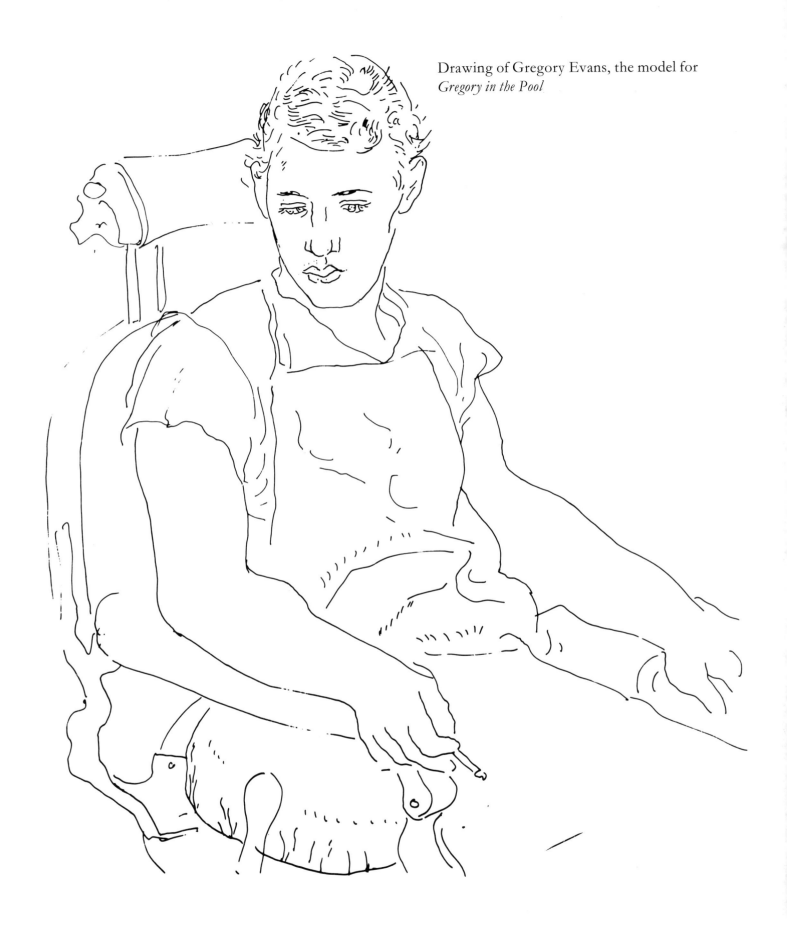

Drawing of Gregory Evans, the model for
Gregory in the Pool

Day Pool with Three Blues (Paper Pool 7), 72 x 85$\frac{1}{2}$ (183 x 218)

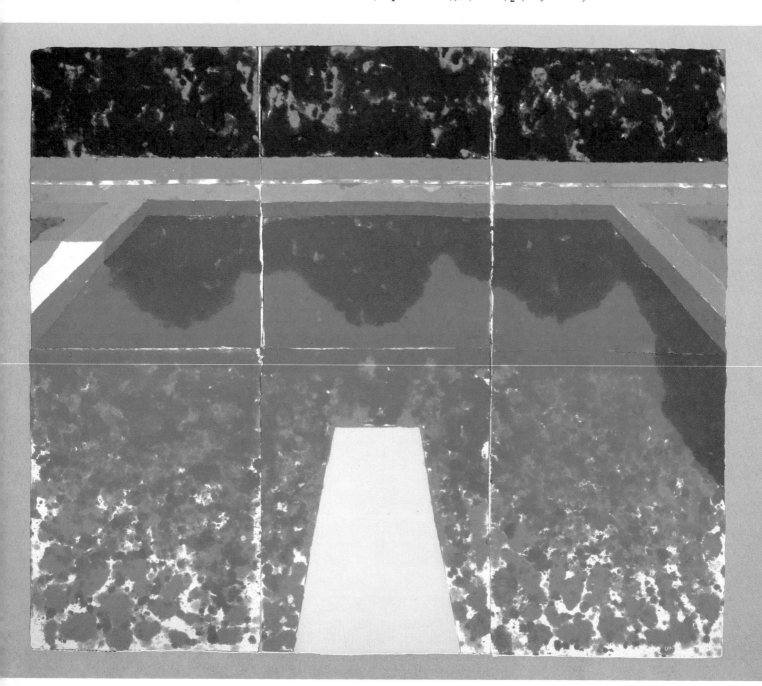

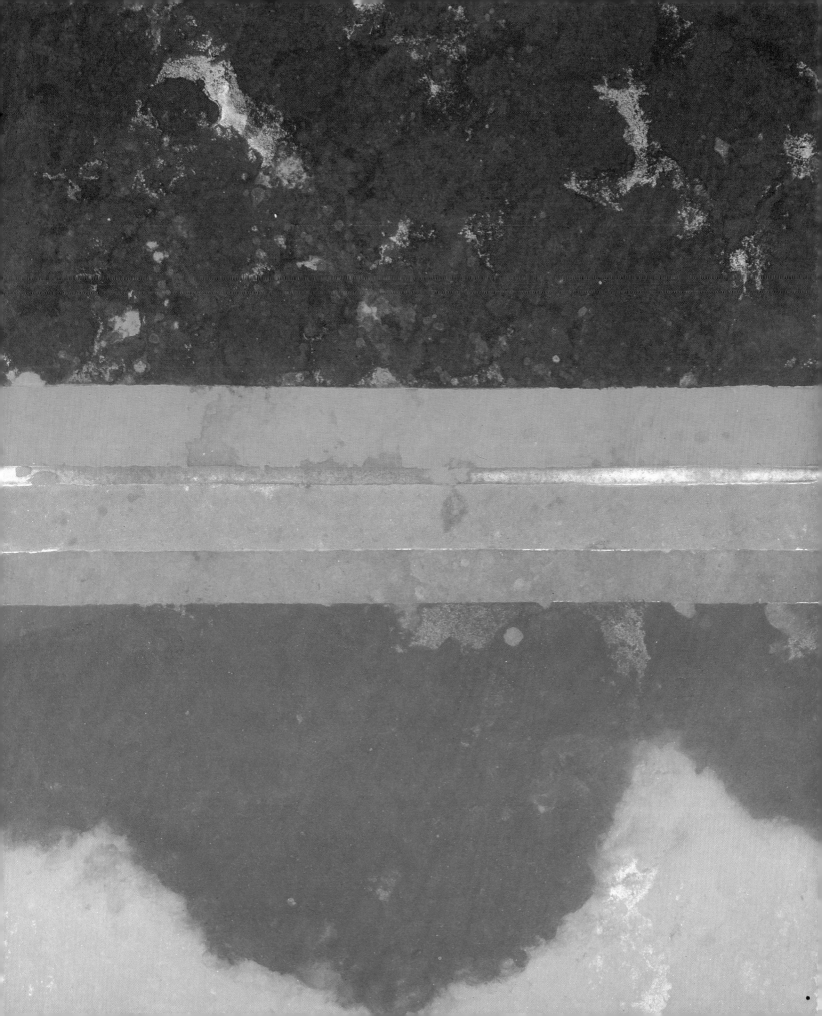

Pool with Reflection of Trees and Sky (Paper Pool 8), 72 x 85½ (183 x 218)

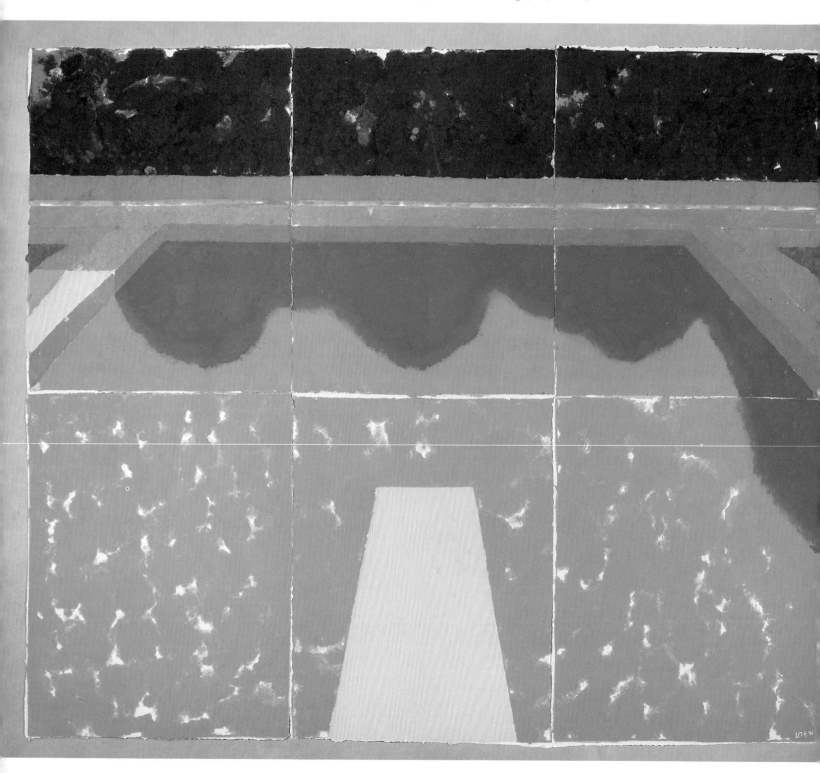

Pool with Reflection and Still Water (Paper Pool 9), 72 x 85½ (183 x 218)

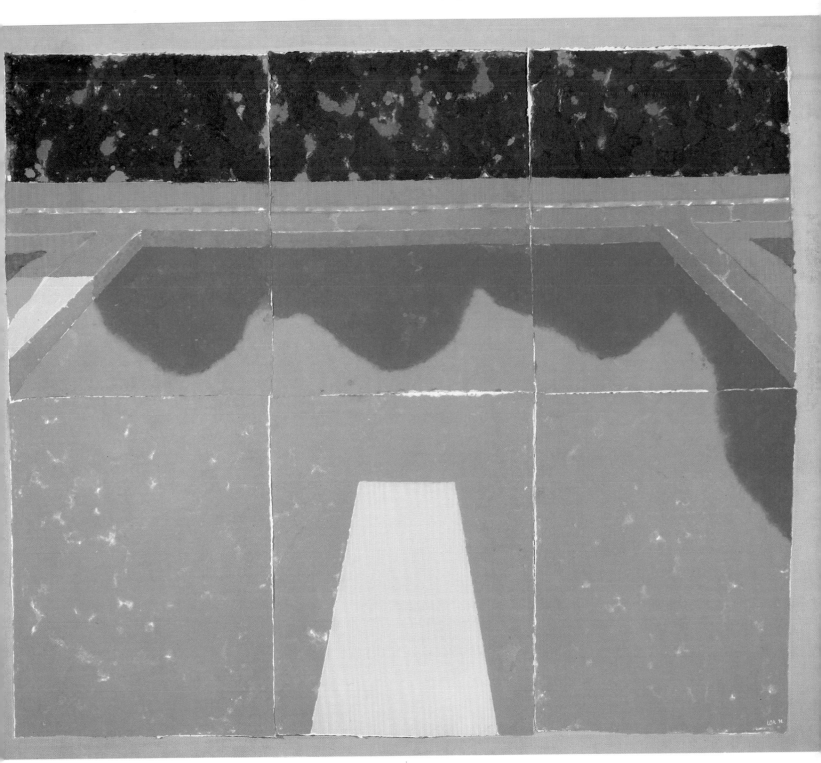

My driving licence had come, in the meantime, and I was wondering, should I leave or not. I had begun to get quite excited by the process and Ken himself was very excited – he is a very energetic person; I have never worked with somebody with more energy; it was fantastic. He was willing to work any hours; it didn't matter. And if I was turned on, we would just work and work although it was a lot of physical, very tiring work. In fact, we worked for forty-five days and only took one day off in the end; I didn't even keep count; Ken did.

One evening, when we had finished work, I was saying to him, the point about water is you can look at it in so many different ways; it's always different; you can choose what to look at, you can say, your eyes will stop here or there. And I said, let's go look at the pool now, and he turned on the lights in the pool. Then I noticed that at night you don't look at the surface at all; all you can do is look right under it, because the light from within the pool stops at the surface of the water and everything above it is black. You can see the steps and the rest of it, but the light right under the diving board becomes black. And I thought that was very exciting, and I said, that's what we will do tomorrow, we will change it all around. We can use the same mould and just add the steps in; and that's what we did. I was using my hands in the pulp, trying to blend colour into colour. These have the most mysteries; they looked, they even began to make the swimming pool begin to look mysterious. Somebody came to see them and he said, it looks as though it's all from *The Magic Flute*, on which, as I said, I had been working before.

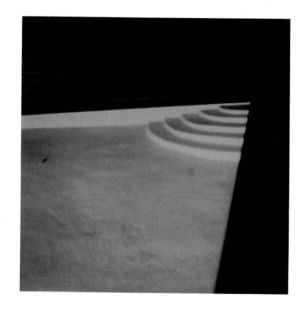 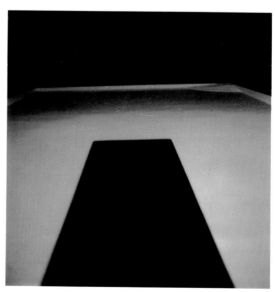

Polaroid photographs of swimming pool at night and
(*opposite*) *Midnight Pool* (Paper Pool 10), 72 x 85½ (183 x 218)

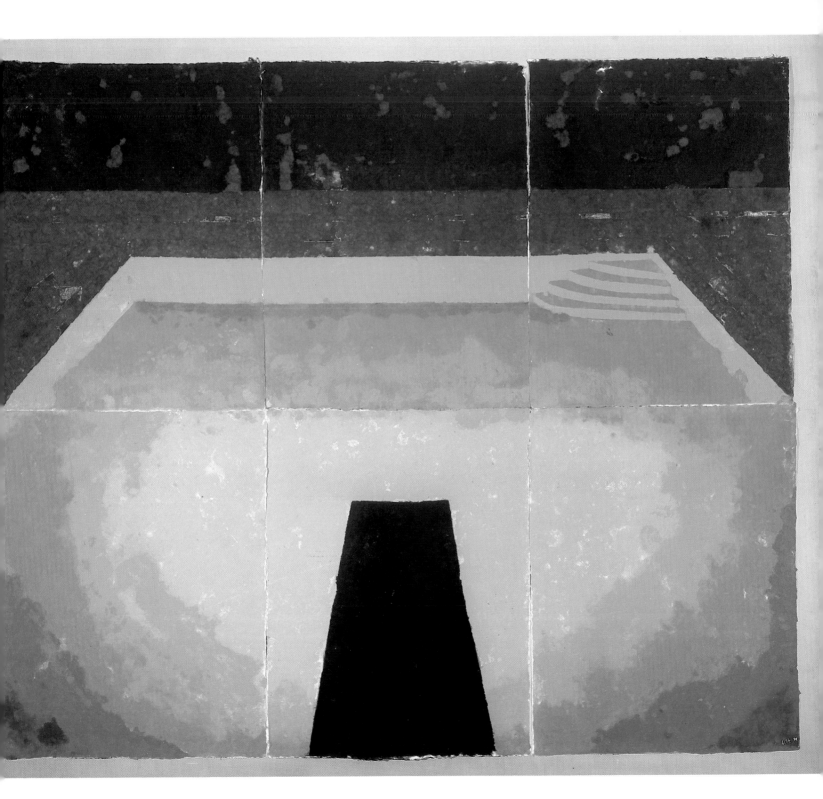

Polaroid photograph relating to night Paper
Pools and (*opposite*) detail of *Schwimmbad
Mitternacht* (Paper Pool 11)

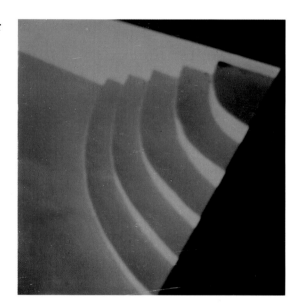

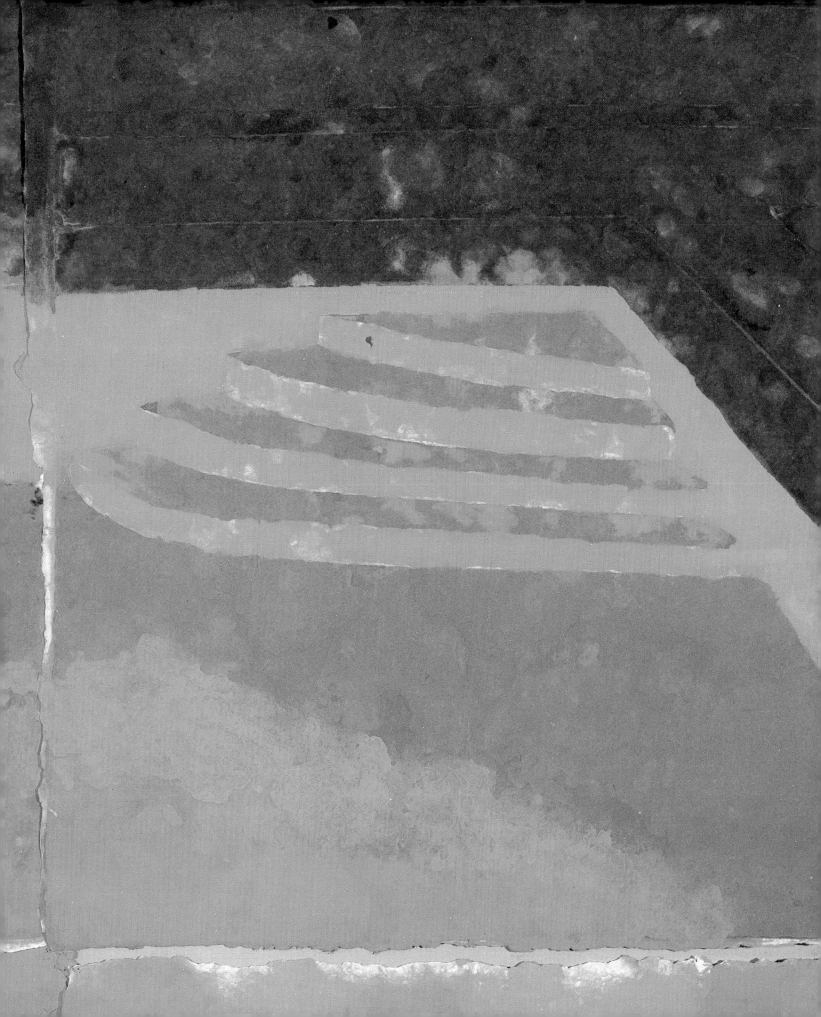

Then I said we could do other compositions. If you move round the corner and the sun is really bright at midday so the light is completely overhead, you can sometimes look on the surface or you can look through it; and if you look through it, you see something else, you see the shadow of the diving board on the bottom. So then I said, I'll draw out another composition, and I drew it out very simply, and we made the mould again. The very first one we made was hideous and I tore it up; all the colours were wrong; somehow pink had crept in. Then I realized that if the shadow of the diving board was straight, it meant the water was extremely still, while shadows on water curl and move about; so

Schwimmbad Mitternacht
(Paper Pool 11),
72 x 85½ (183 x 218)

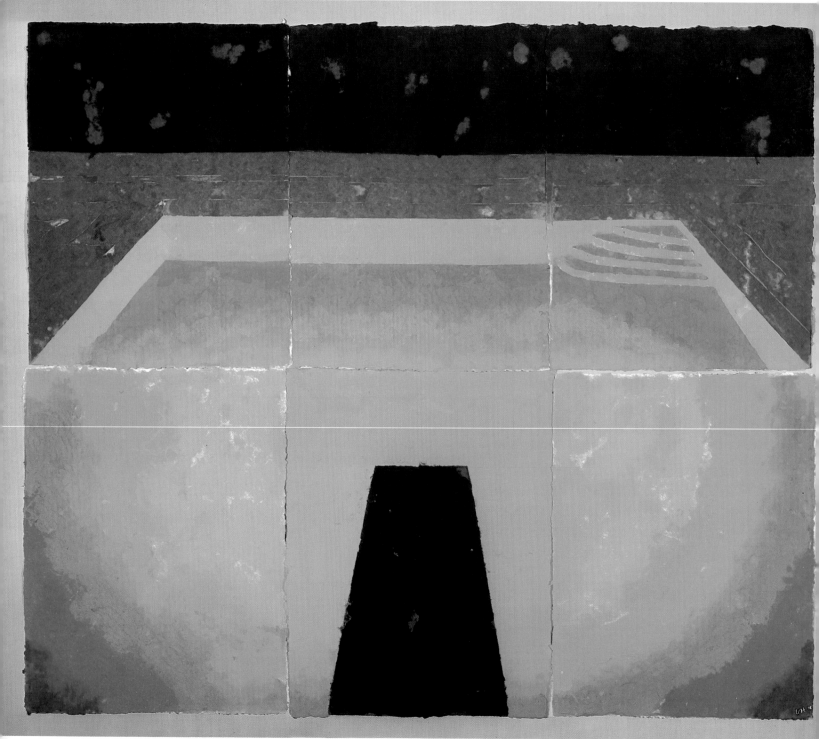

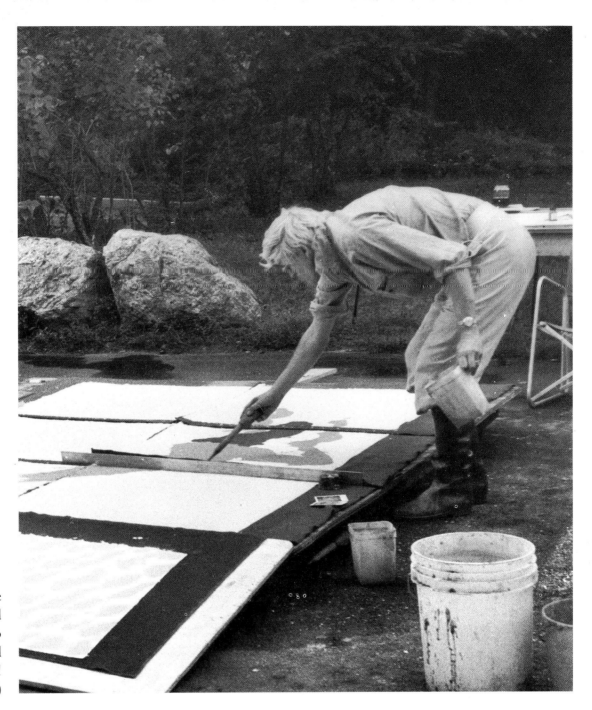

Hockney drawing the figure on newly formed sheets of wet paper pulp with liquid dyes applied with a kitchen baster for *A Large Diver* (Paper Pool 27)

I altered the mould and the shadow began to dance; while you are still looking at the surface, the water is moving about. But I still thought that it wasn't quite right. I wasn't catching all the light on the water and we had to work on it more. Then I began to realize that the bottom of the swimming pool catches more light; so there are bits of white showing through the colour. For the little green, squiggly marks which are done on the surface, I would make the picture, then half press the paper and then add the little green marks; they look very watery because they are not made with a brush at all but with very strong pigment squeezed out using a kitchen baster, forming a shape that you couldn't ever make with a brush.

53

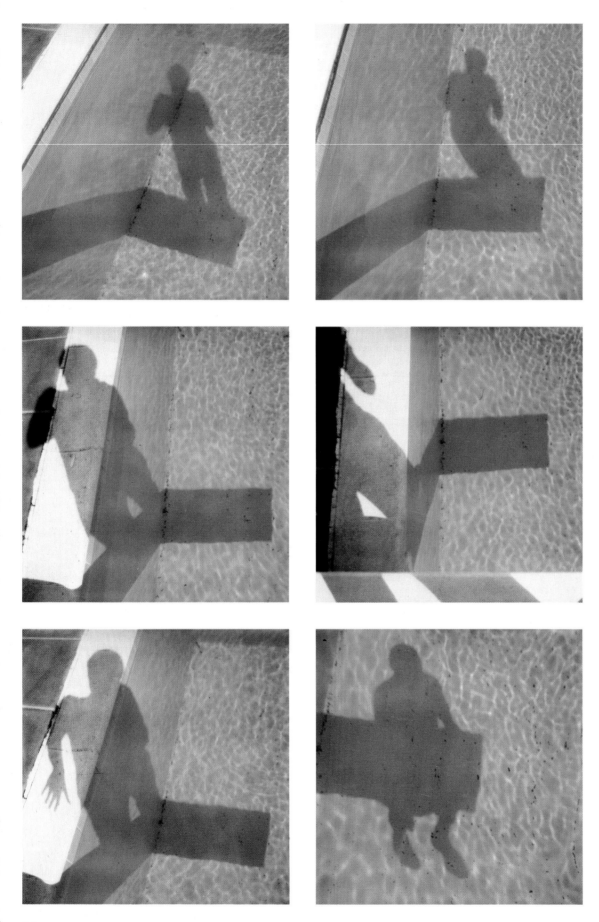

Shadows in the pool

Diving Board with Still Water on Blue Paper (Paper Pool 12), 72 x 85½ (183 x 218)

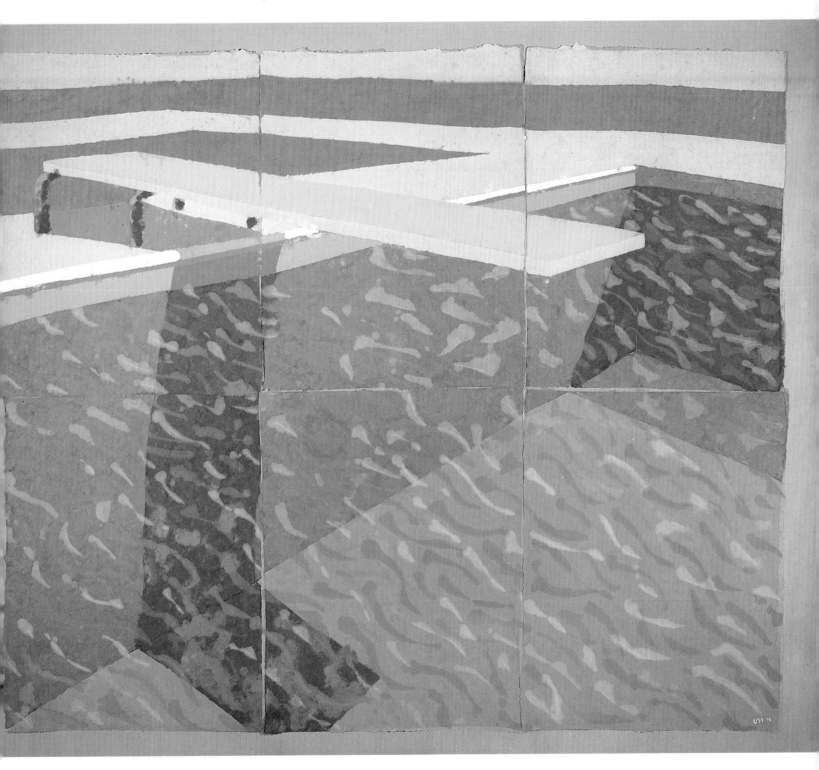

Pen and ink drawing for Paper Pools 12 to 15, done as study
of diving board reflections in the water

Plongeoir avec ombre (Paper Pool 13), 72 x 85½ (183 x 218)

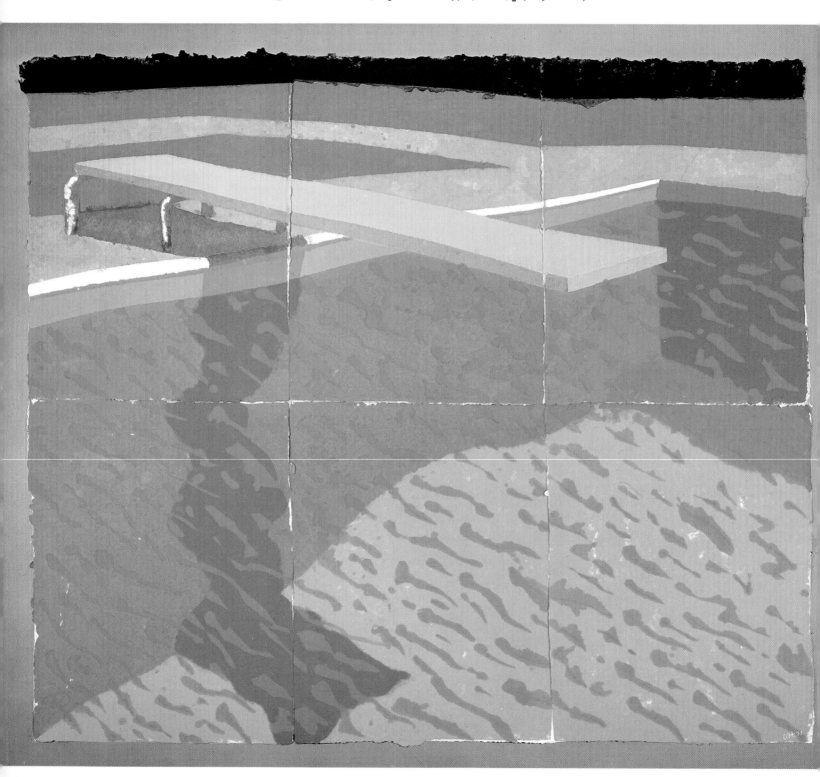

Sprungbrett mit Schatten (Paper Pool 14), 72 x 85½ (183 x 218)

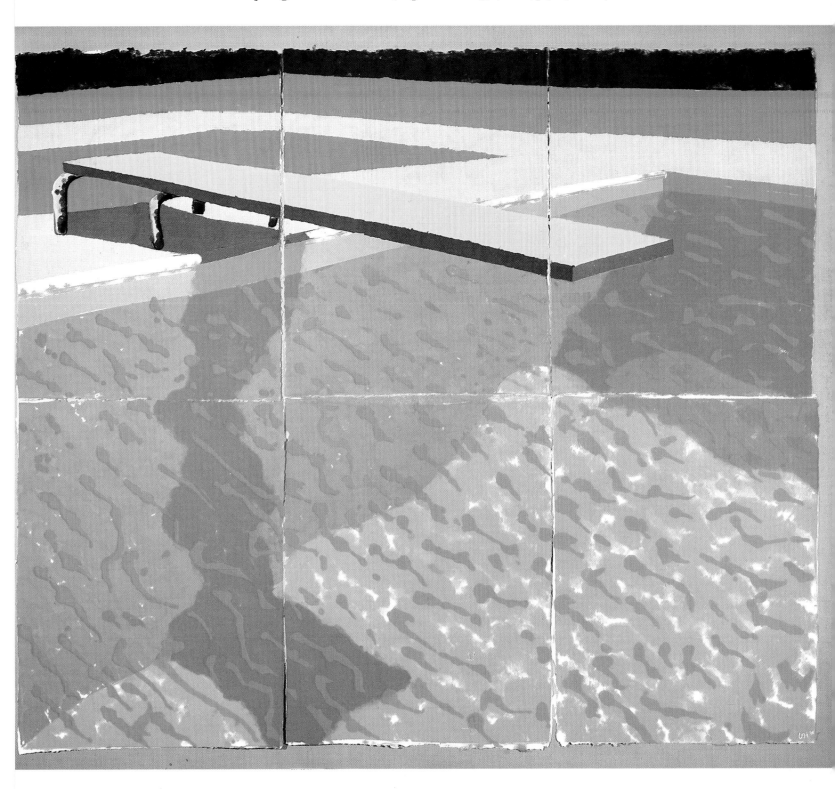

Every time we'd finished something I'd say, stick them up on the wall; and we kept putting them up. We'd sit there and look at them. And I said, maybe we can go on and on and expand the size. I was trying to tell Ken what would be possible to do. Then I said, you know, if somebody was swimming, and I got Gregory to keep jumping into the swimming pool, underneath the water, the distortion of the figure becomes very interesting. And if you photograph the distortion, it freezes it: the arms become long, the body goes odd and you begin to look like a lobster or a crab. Then I said, maybe we could add this onto the other one and make an even bigger picture. These ended up fifteen feet long and it took about sixteen hours to make the paper. And these even bigger works with the figure were made without moulds. For the straight lines, we simply put down a piece of metal and poured the colour on.

All this time I was thinking, should I go to California or shouldn't I; I wanted to paint. Finally I realized, because I had these buckets full of blue and buckets full of green, if this was paint and I was doing a painting I wouldn't have the nerve to just throw it around like this and pour it on. With these pictures I was prepared to do this and, at the end of the day, to tear them all up if we didn't like them. If you go through all the trouble of stretching the canvas, you are not too keen on tearing it all up; if somebody else would do it for you it'd be easy, but otherwise. . . .

Polaroid photographs of underwater figures

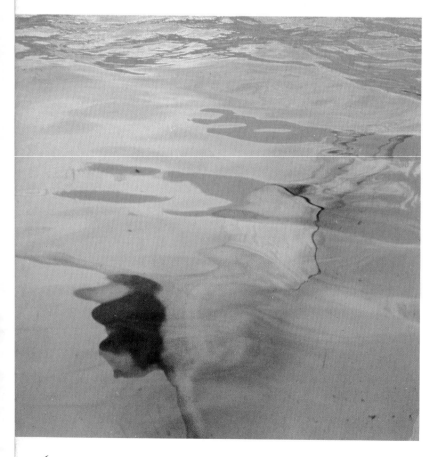
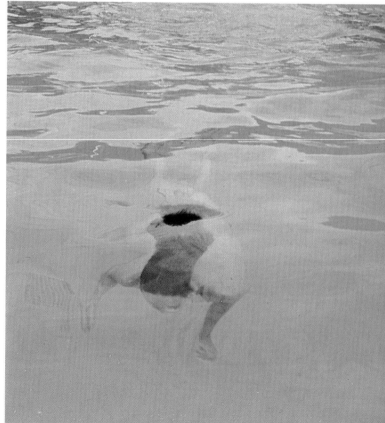

Diving Board with Shadow (Paper Pool 15), 72 x 85½ (183 x 218)

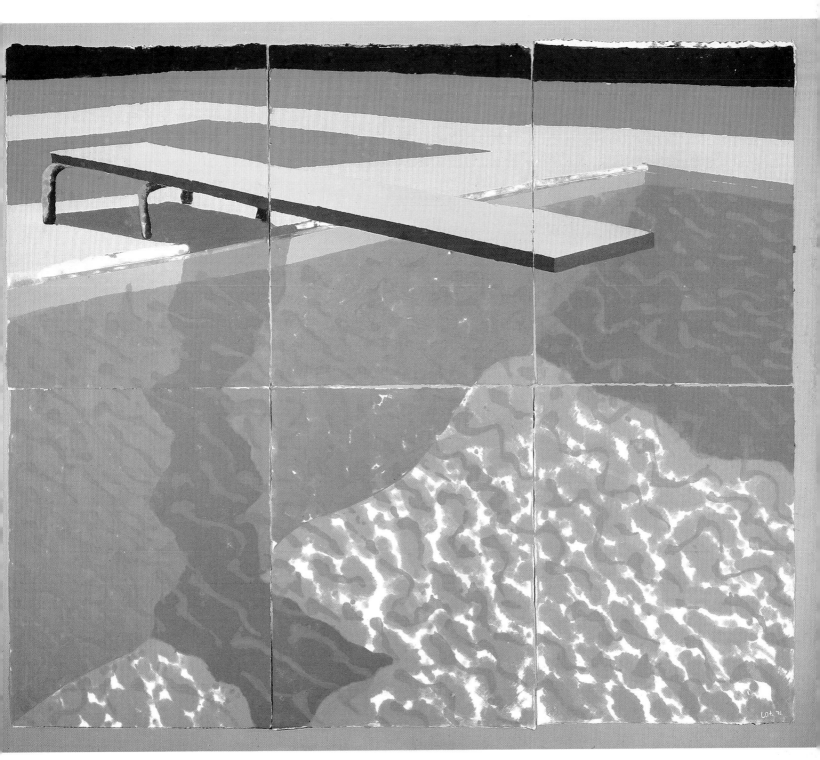

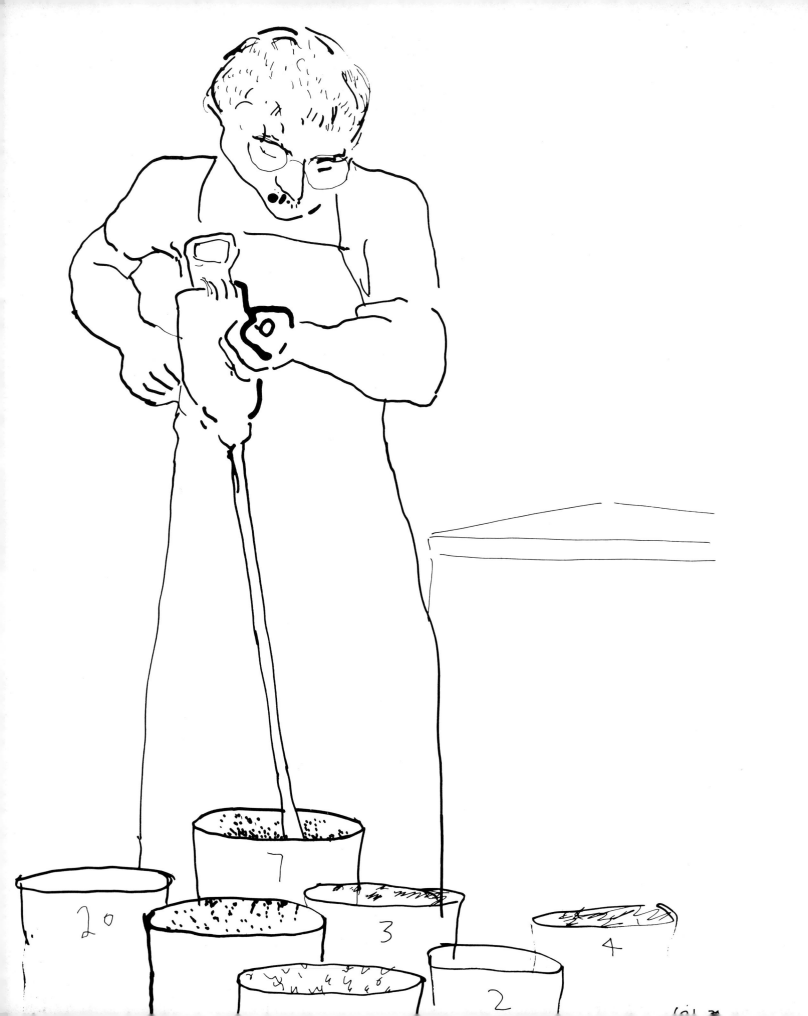

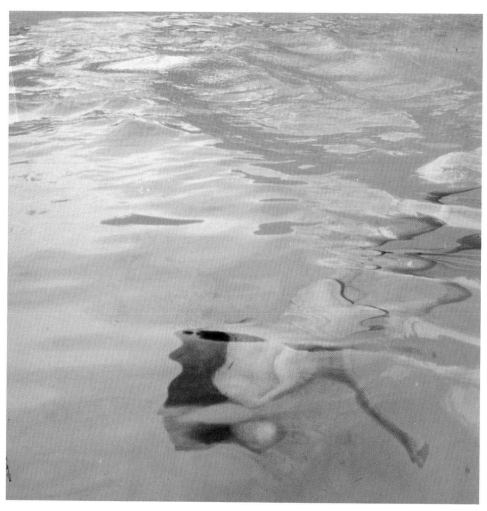

Polaroid photograph relating to Paper Pool 16

Swimmer Underwater (Paper Pool 16), 72 x 85½ (183 x 218)

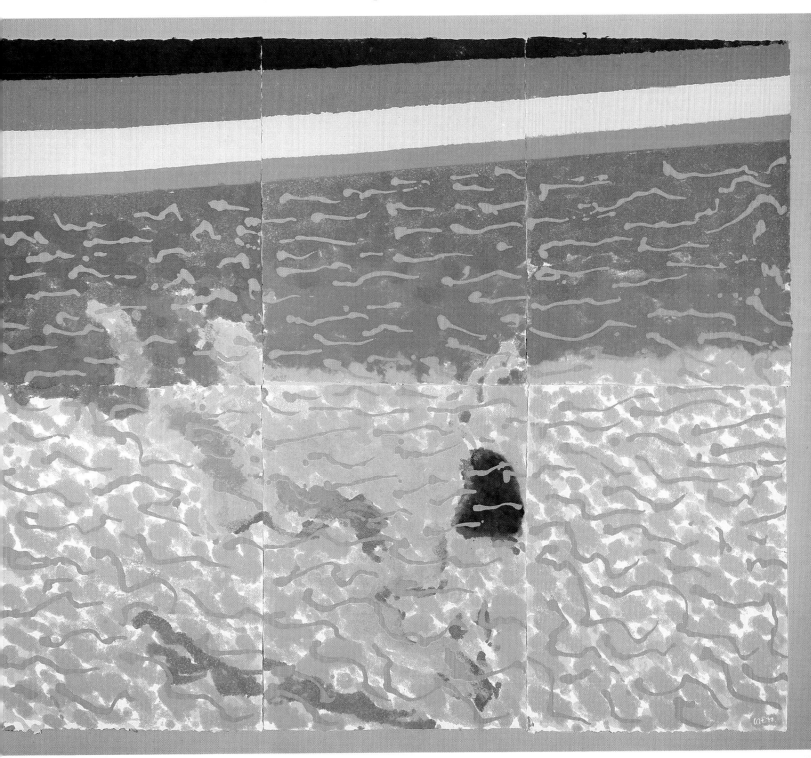

I thought that I hadn't quite got the figure right at first, so we worked on it a bit and I sat and watched figures under water a lot more. If somebody went under the water or made a splash, the splash was on the water's surface, you could look into the water and the figure was distorted. For doing the splash, I drew it on a piece of cardboard, cut it out, placed it on, like a stencil, and then I poured blue around it and lifted the cardboard off; for the white I simply used white pulp. I threw it down as the splash would occur. At first, I didn't know what to think of it, and Ken thought it was wonderful. I said, I'm not very sure, I don't know whether it actually works; I think we should try another one. And we did another one.

A Diver (Paper Pool 17), 72 x 171 (183 x 434)

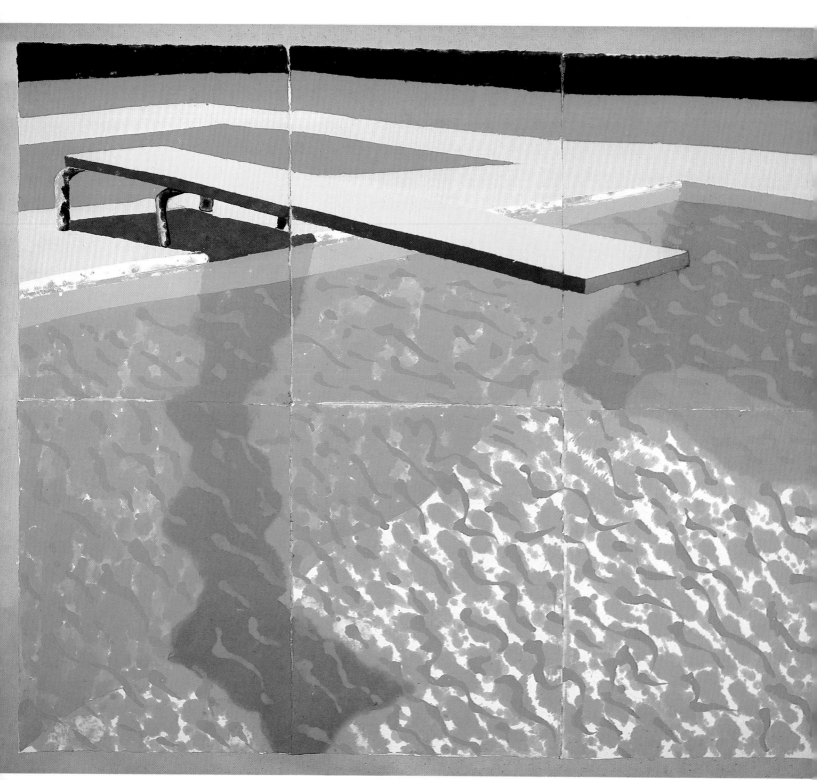

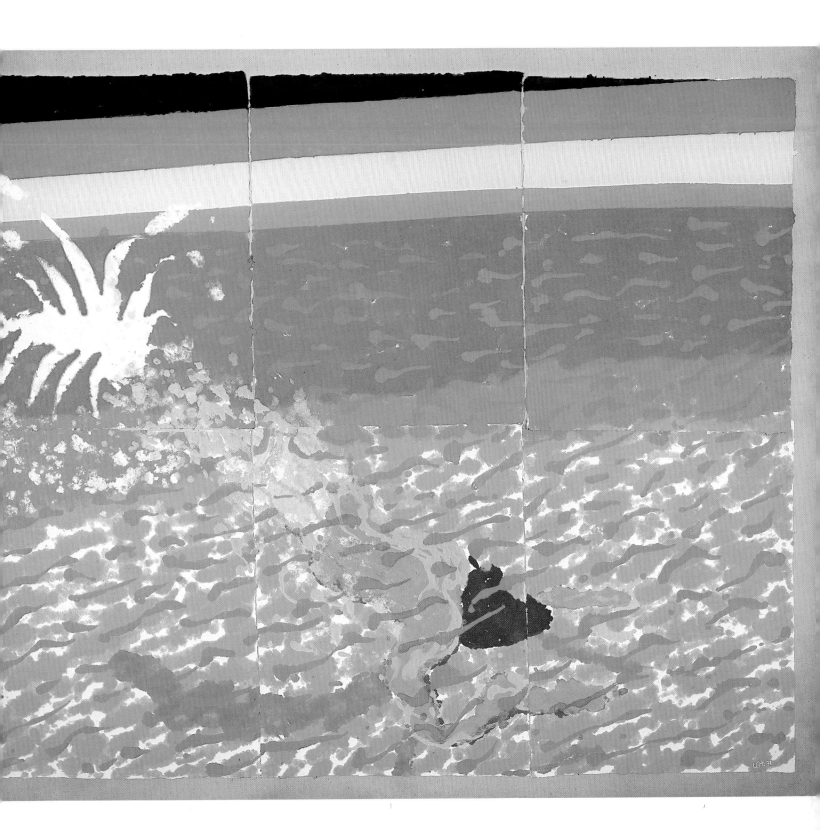

Making light on the water of Paper Pool 18

Le Plongeur (Paper Pool 18), 72 x 171 (183 x 434)

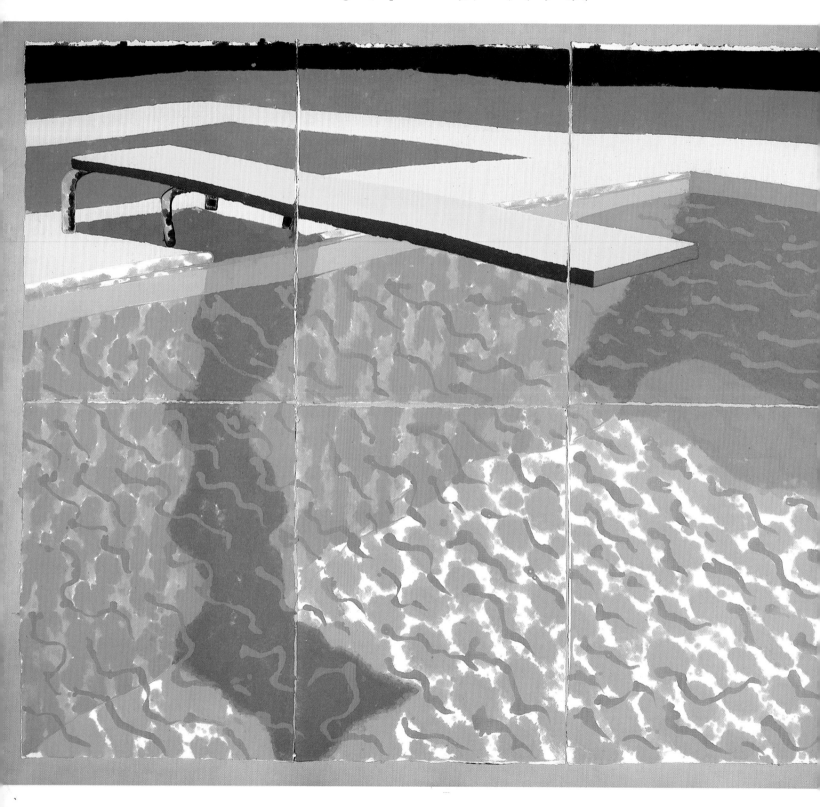

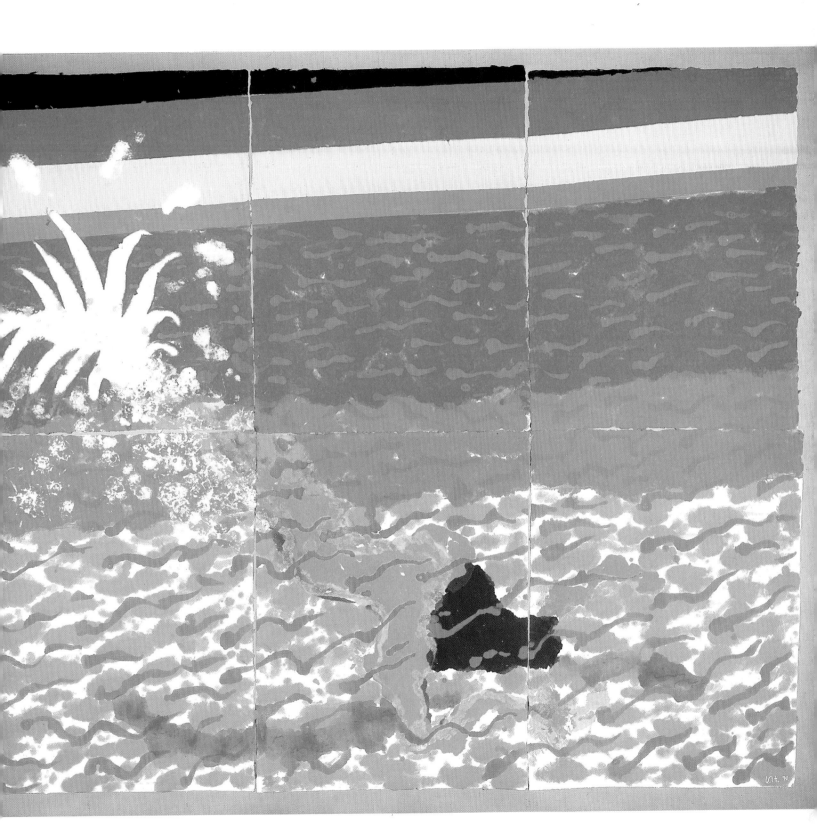

Hockney working on *Le Plongeur* while looking at *A Diver*

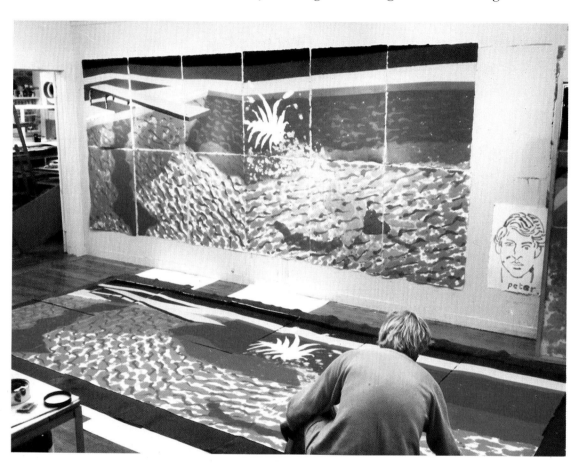

I thought the figure was better now; it came through directly where the splash was. But although I thought that this was a bit more successful, it still didn't sparkle enough; you were supposed to be looking into a transparent thing. We kept it up on the wall – it looked very big on the wall – and I said, we'll go back to some other kind of work for a while, maybe a night scene; let's go back and make the night pools better. We kept doing things wrong. Each piece of paper had to be separated by about a foot, so you had to keep a clear overall picture in your head of what you were doing and sometimes you couldn't tie it up exactly.

Piscine a minuit (Paper Pool 19), 72 x 85½ (183 x 218)

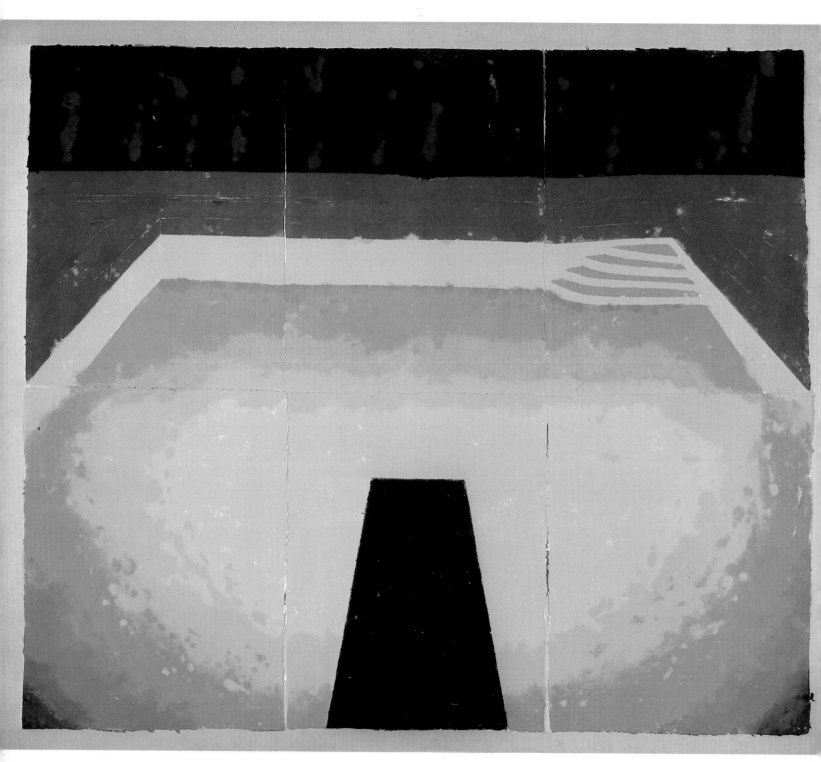

Une autre piscine a minuit (Paper Pool 20), 72 x 85½ (183 x 218)

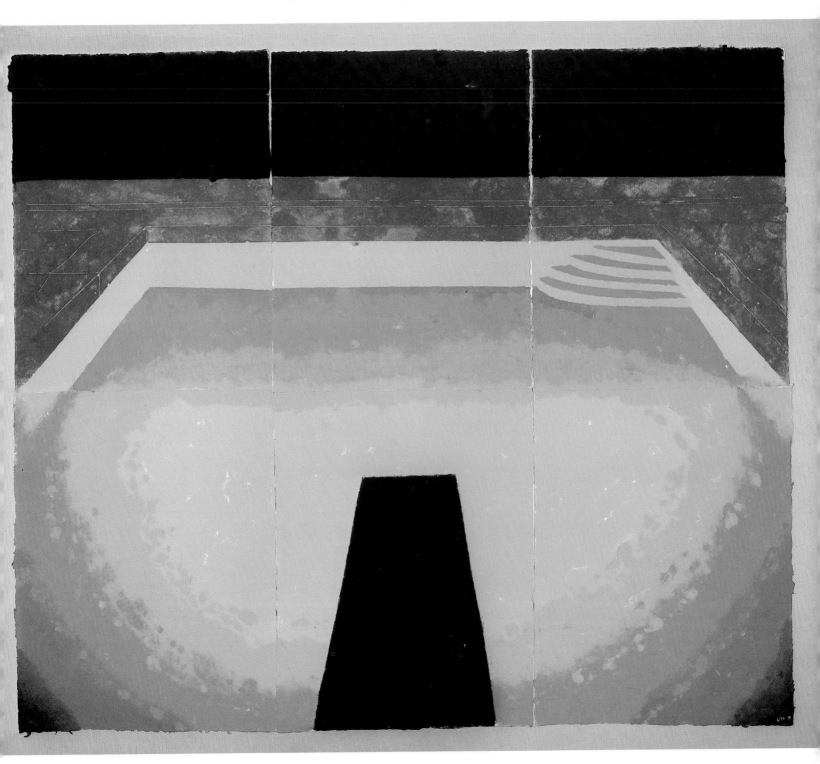

Then, as the time had gone on and the sun wasn't coming out as much now and the days were cloudy, the water began to look a bit different and the tones were all-over blue. It rained and when it rained the steps started with a deep blue at the top and the blue faded as the water got more opaque because of the rain, and I thought the water looked wetter, it was all wet, now it was all about wetness; the subject was now more about the wetness of the water; there was no transparency, you couldn't see through it. We'd go from a deep blue to a pale blue. We'd put on a layer of colour and I'd wash it down with a bucket of white pulp, then another bucket of white pulp for another layer and another. You had to use enormous quantities of water; it took a thousand gallons of water to make one of these, which seems to me an awful lot; in a watercolour you use a cupful.

Polaroid photographs relating to (*opposite*) *Pool on a Cloudy Day* (Paper Pool 21), 72 x 85½ (183 x 218)

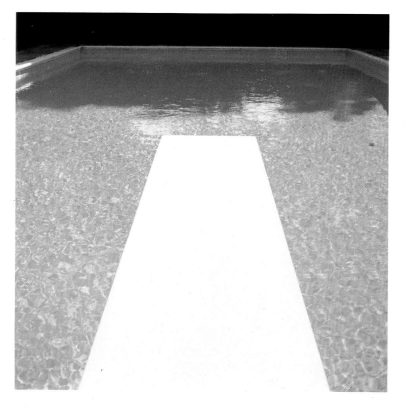

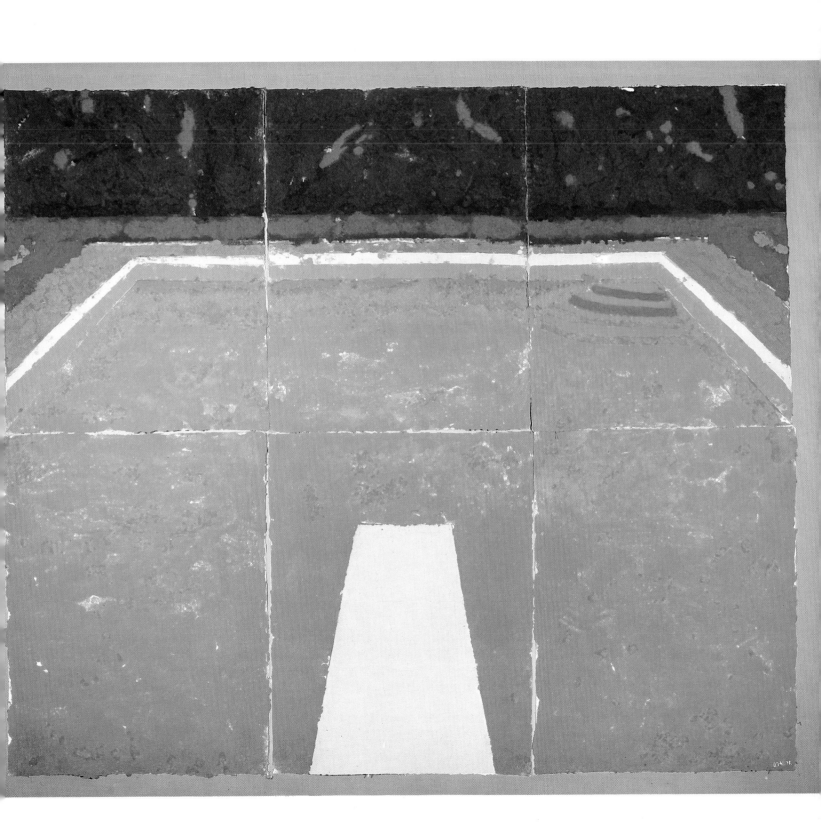

Pool on a Cloudy Day with Rain (Paper Pool 22), 72 x 85½ (183 x 218)

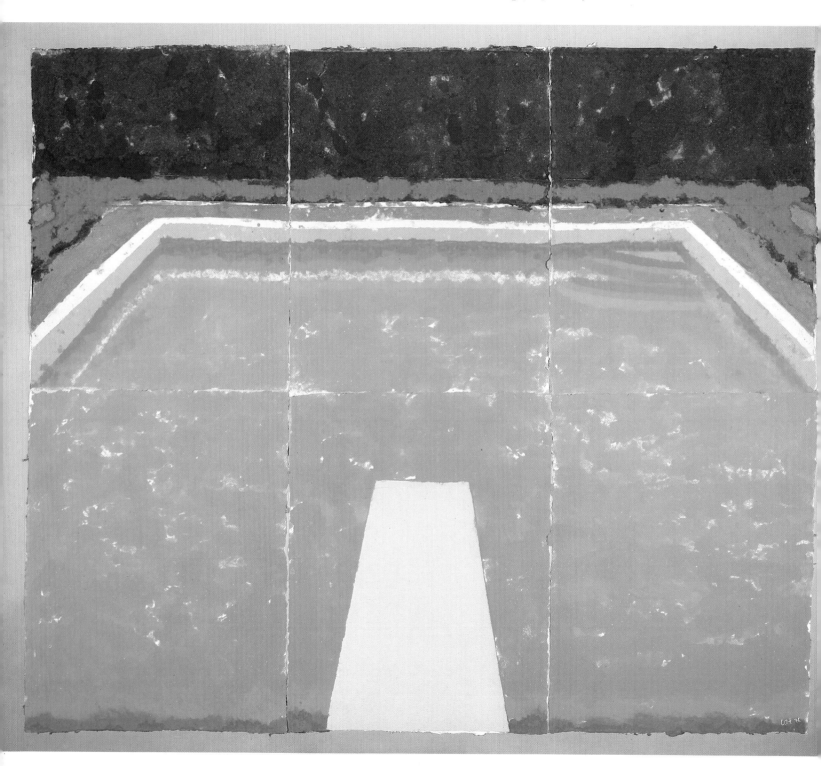

Oversized Pool (Paper Pool 23), $81\frac{1}{2}$ x $92\frac{1}{2}$ (207 x 235)

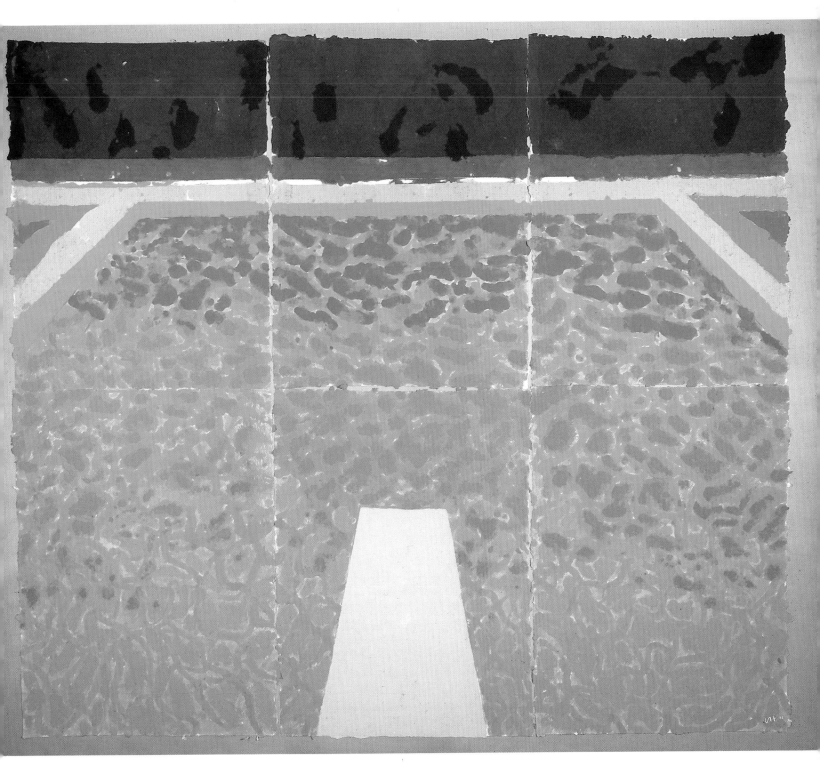

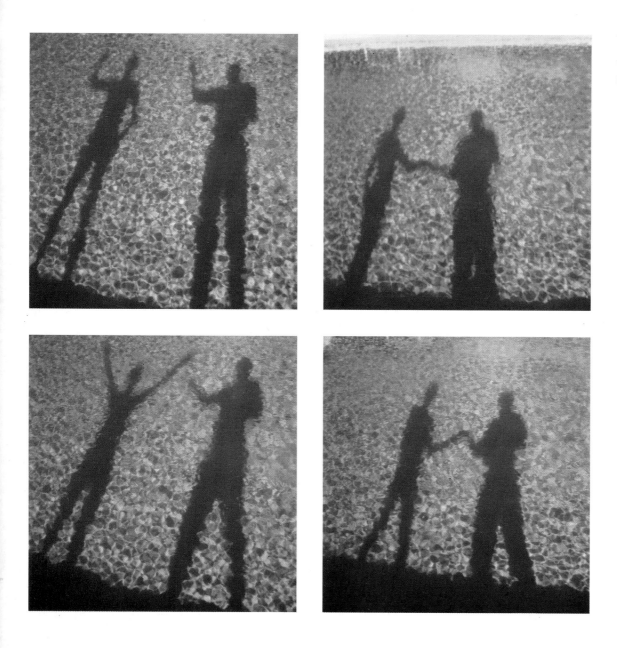

Polaroid studies of patterns of light on water and reflected figures

Piscine on Sprayed Blue Paper with Green Top (Paper Pool 24), 72 x 85½ (183 x 218)

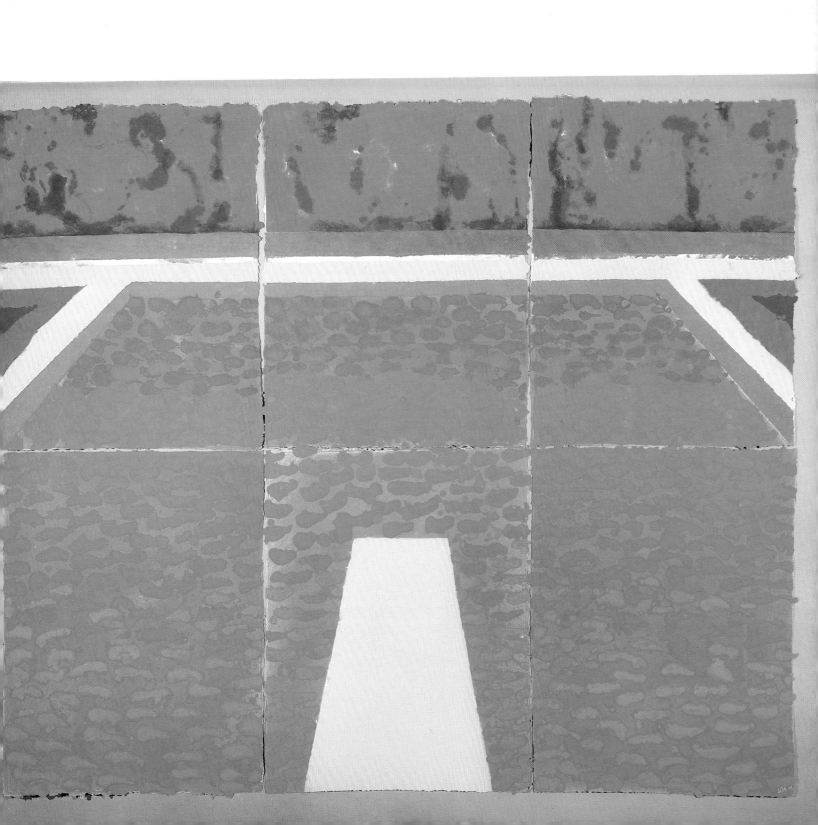

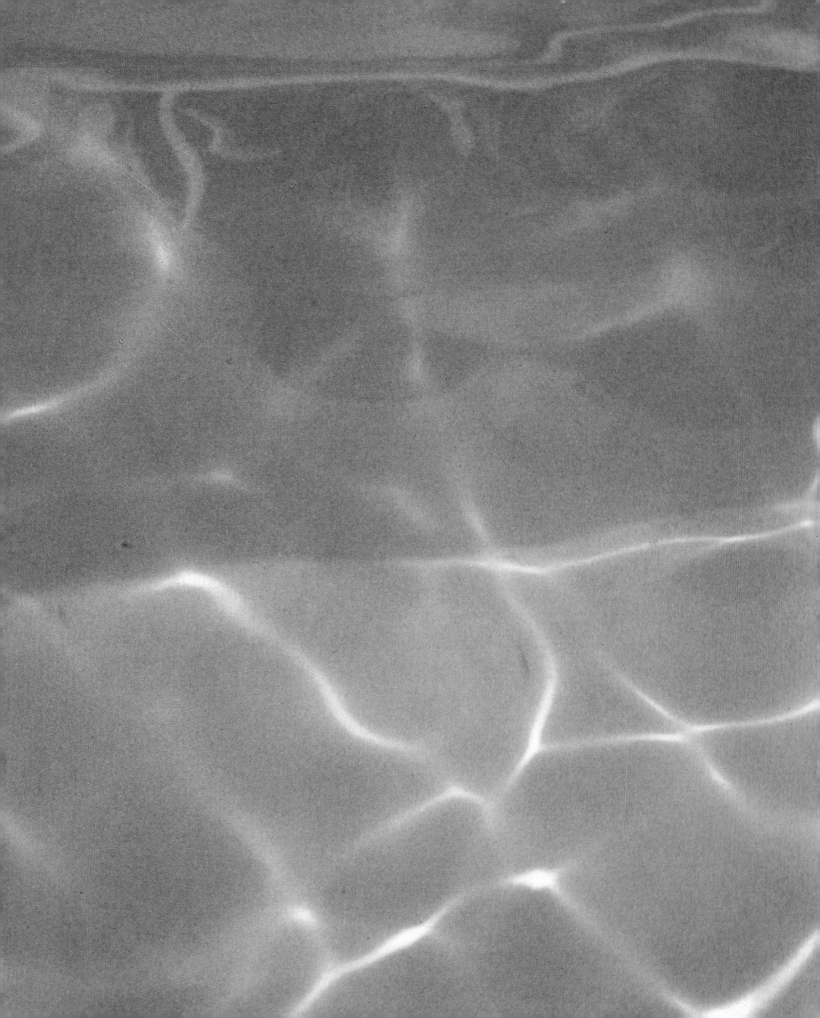

Blown up Polaroid study of light patterns in water

Pool on Sprayed Blue Paper with Purple Top (Paper Pool 25), 72 x 85½ (183 x 218)

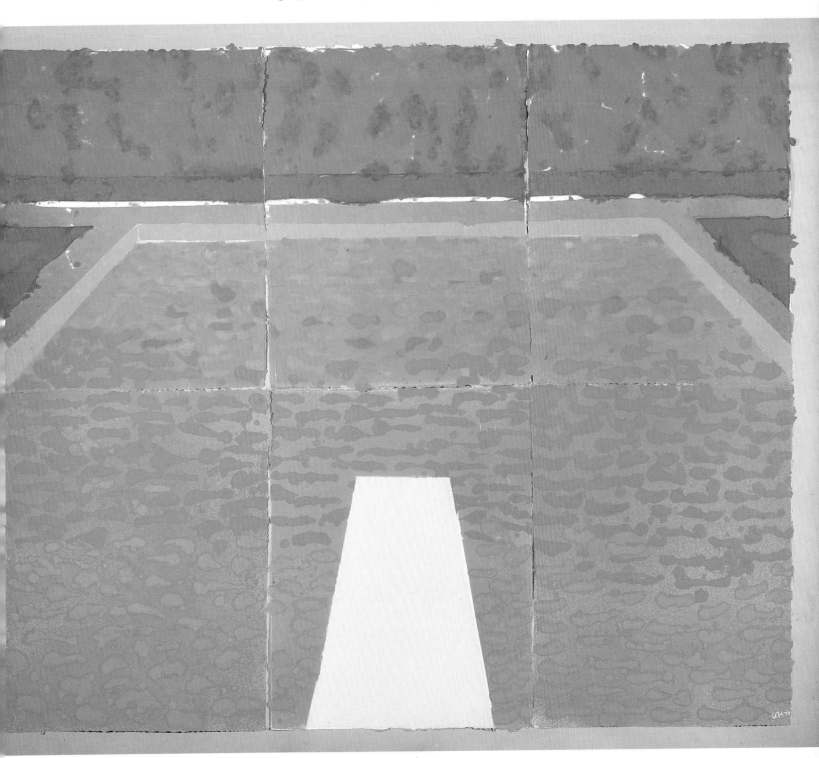

Polaroid studies of reflections of clouds and trees and
(opposite) Pool with Cloud Reflections (Paper Pool 26), 72 x 85½ (183 x 218)

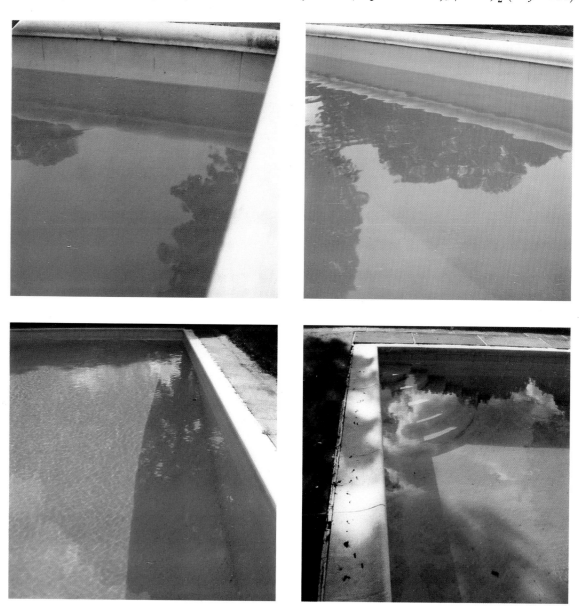

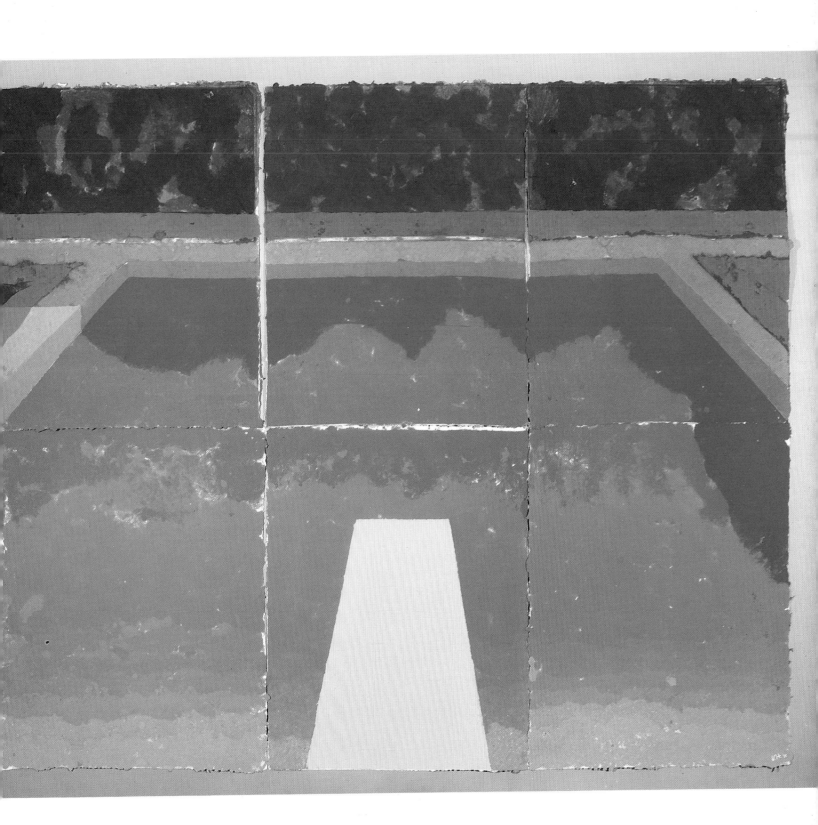

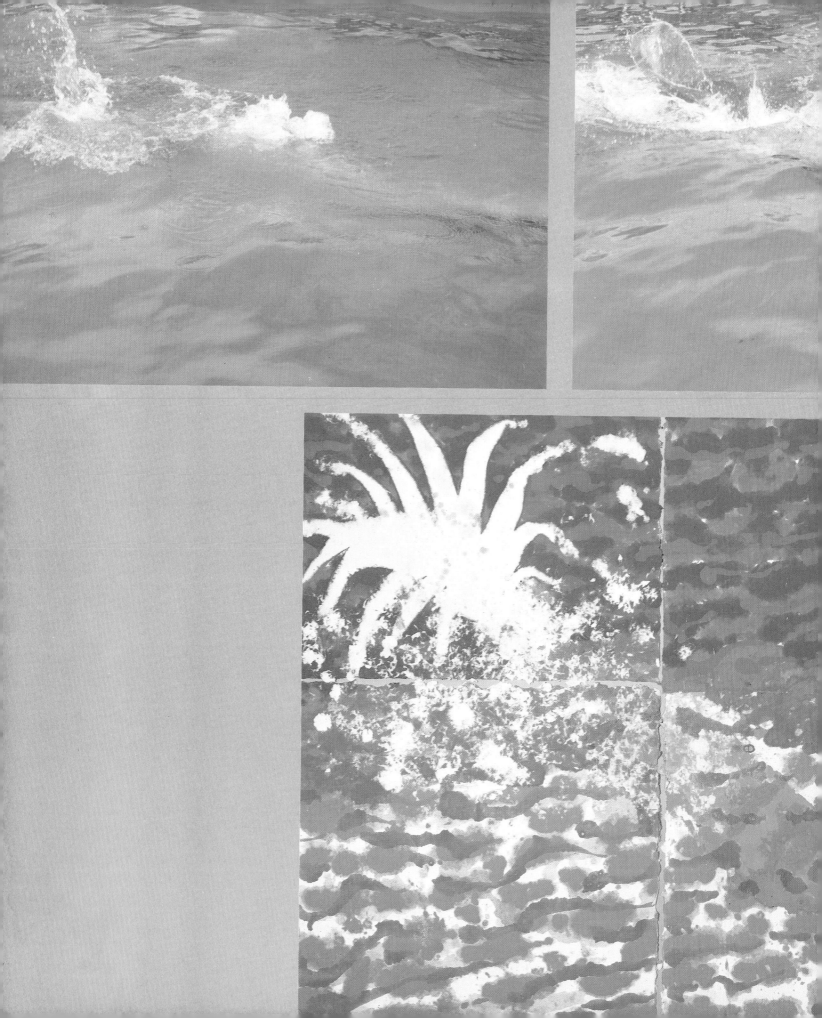

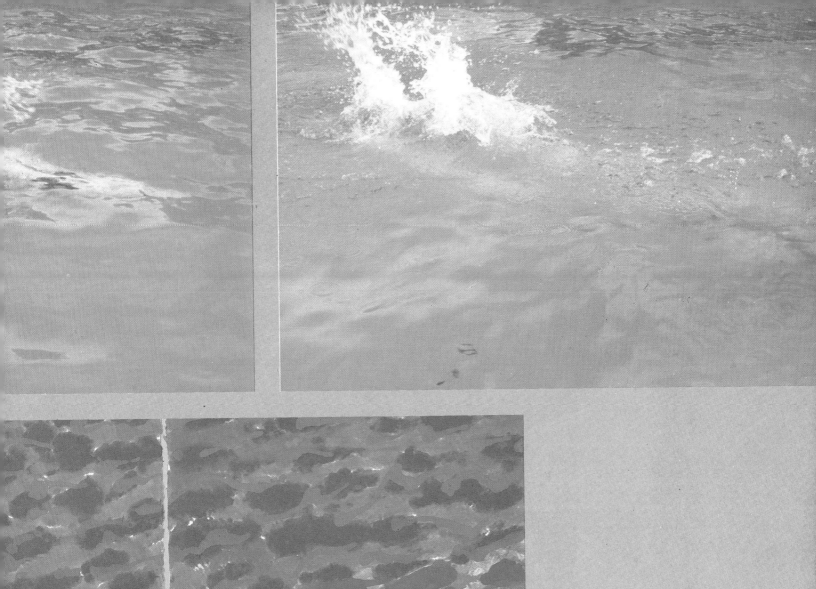

Studies of a diver's splash, and
detail of splash from *A Large Diver*
(Paper Pool 27)

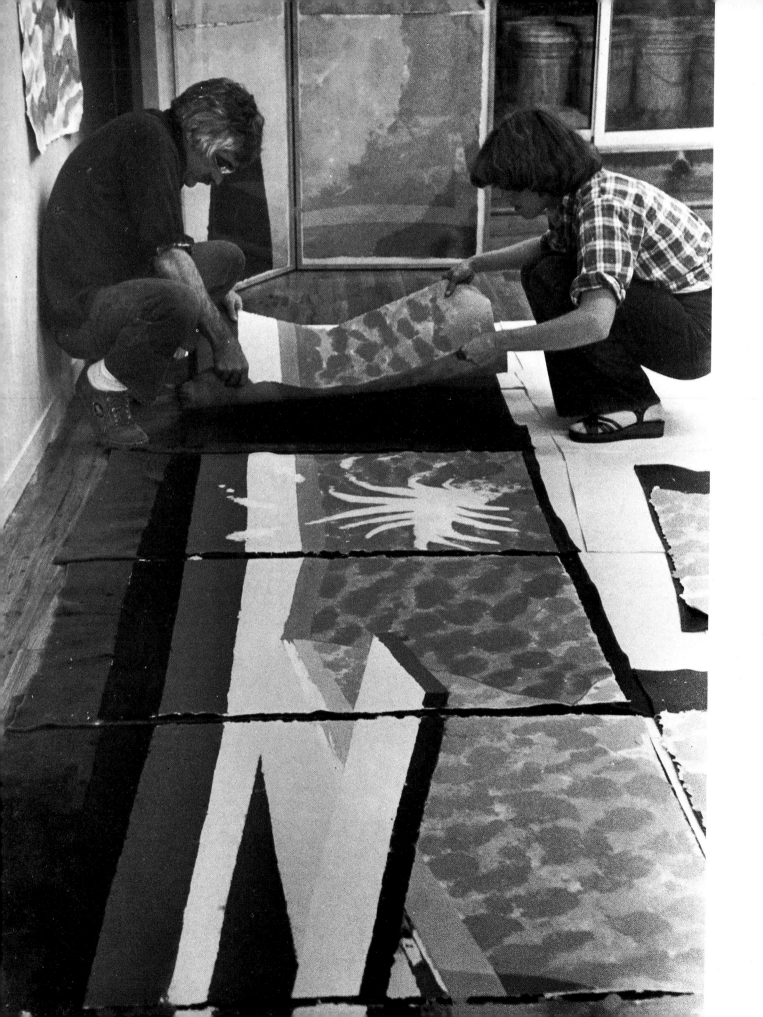

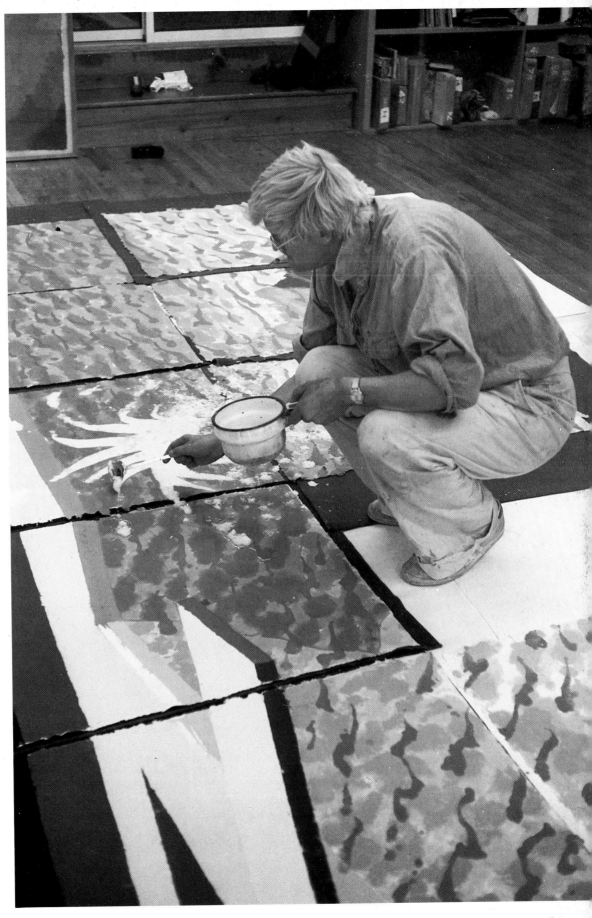

Kenneth Tyler, Lindsay
Green and Hockney
working on *A Large Diver*

A Large Diver (Paper Pool 27), 72 x 171 (183 x 434)

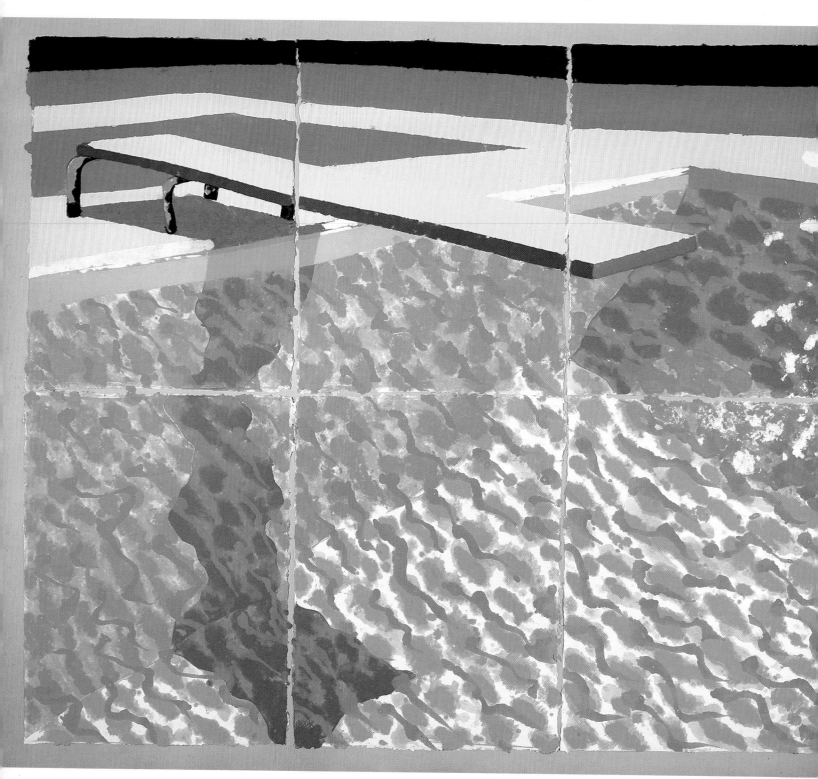

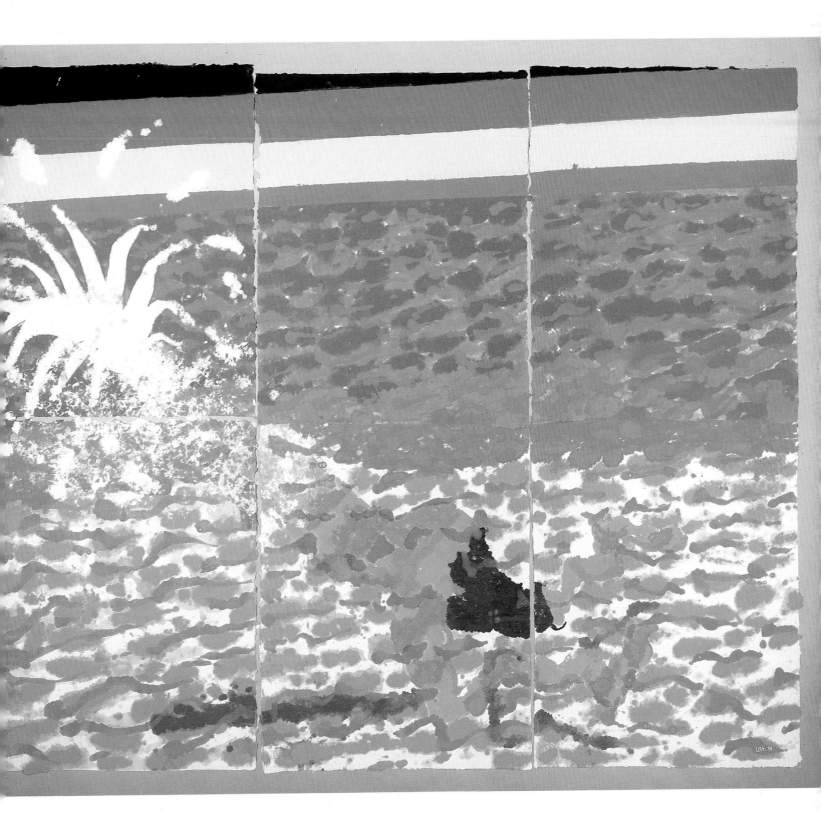

Polaroid photograph, taken at an angle, of coloured paper pulp before it was pressed, showing a detail from *Fall Pool with Two Flat Blues* (Paper Pool 28) and the same detail (*opposite*) of the finished work

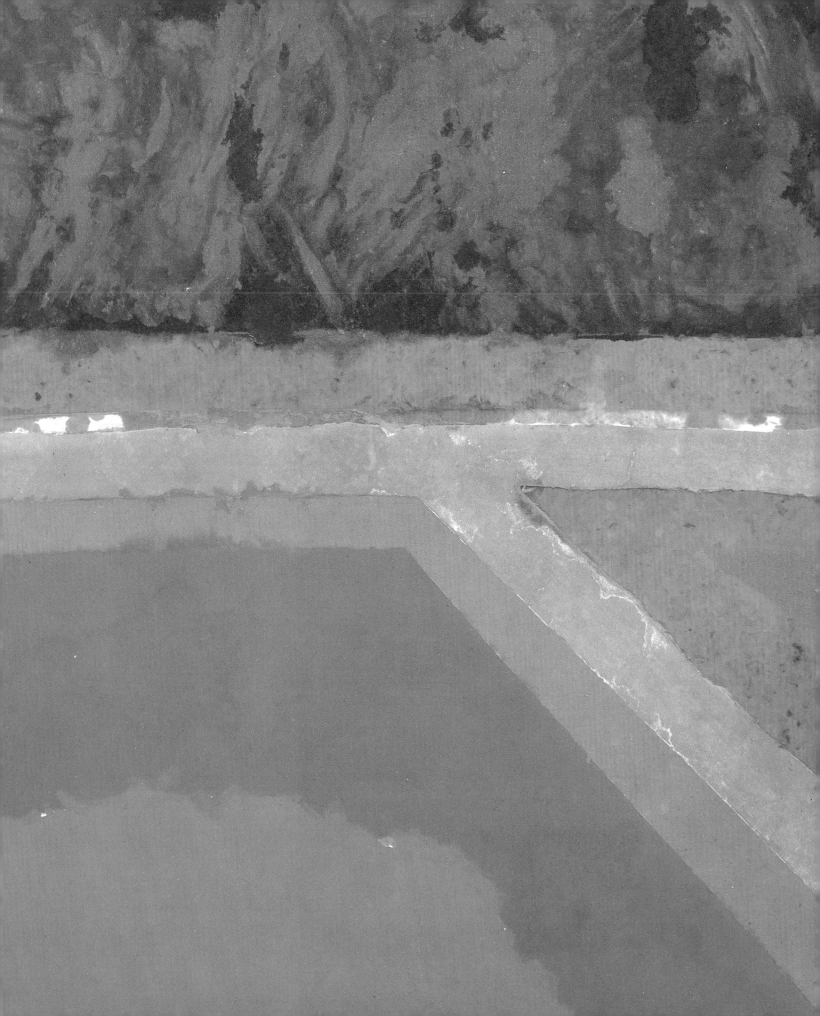

Fall Pool with Two Flat Blues (Paper Pool 28), 72 x 85½ (183 x 218)

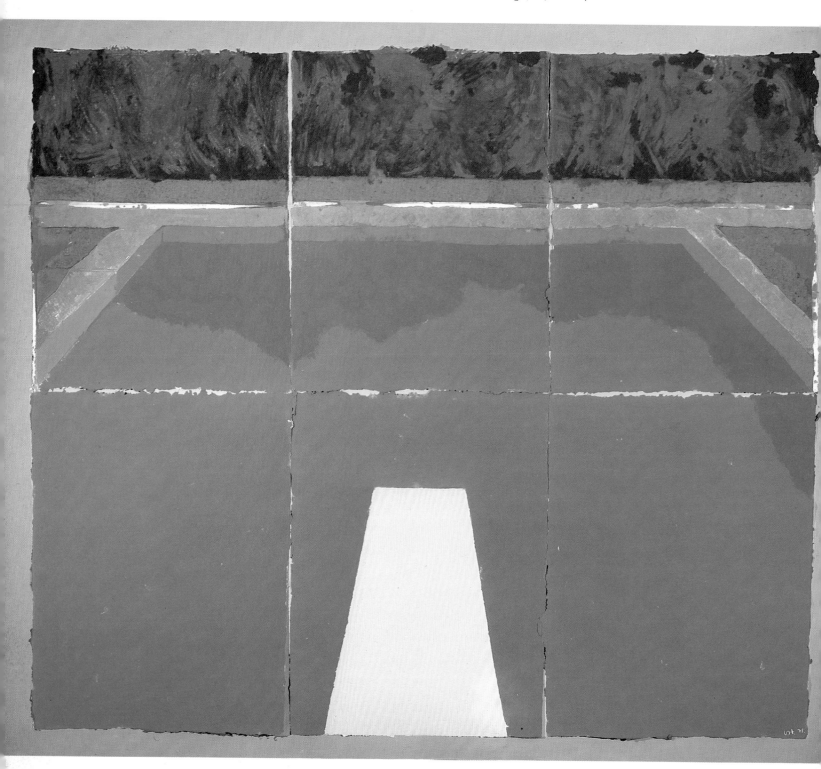

Autumn Pool (Paper Pool 29), 72 x 85½ (183 x 218)

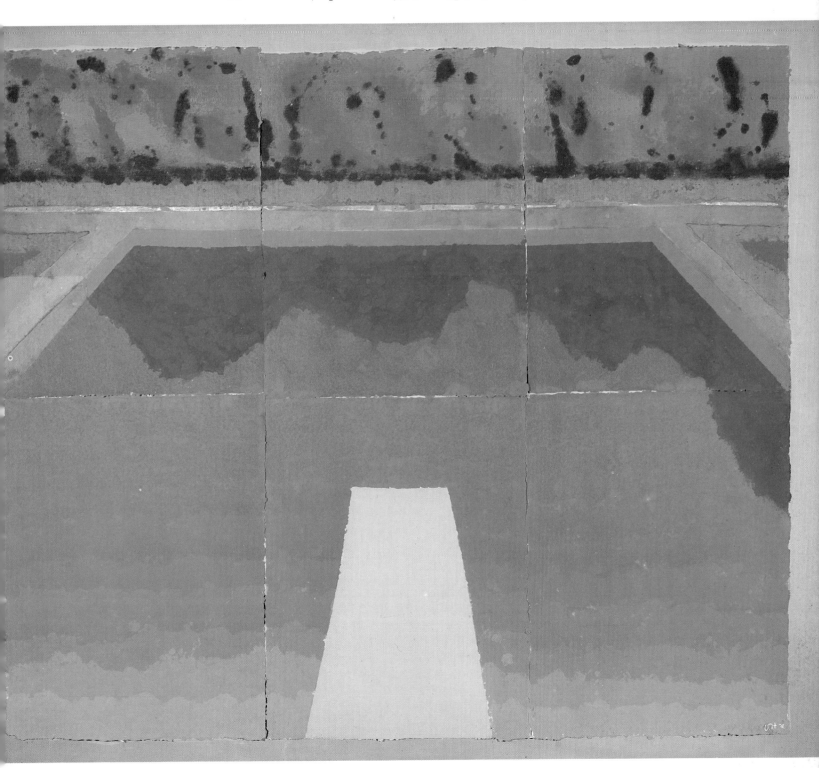

When I finished I said, I'll have to push off to California now; I have to paint. Ken said, you have stayed longer than any other artist who's been here; they usually only stay for two or three weeks. I said, you've been trying to get me here for a long time, you shouldn't complain that I stayed too long.

I don't know if these pictures are worthwhile, really. I must say, they probably look better in real life than they do in reproduction because the paper is very beautiful, the surface, there is no such thing as a flat colour, and they are very subtle at times. They are like paintings, which is why I stayed; if they hadn't been like paintings, I think I would have left after doing the first two or three small ones, I would have thought that was enough. And they also helped me in another way: painting in England before, I kept saying I thought the paintings were getting too gray, too tight and I kept getting finicky and I wanted to be bolder; I figured it was harder to be bolder and these works now allowed me to be bolder. And another thing that was nice about Paper Pools was that you were *forced* to do it that way, you were forced to think of things in another way, you couldn't work in the way you had been doing before and put detail in; somehow, working like that defined another kind of essence of making a picture that couldn't include detail. I think that's why I enjoyed doing it. And as I say, working with someone who has an awful lot of energy is very thrilling. With Ken Tyler nothing was impossible. If I said, could we, he said, yes, yes it can be done.

Now I'm going to paint all about figures; I'm not going to paint about swimming pools; I've done enough now.